IMAGES of America

ILLINOIS AND MICHIGAN CANAL

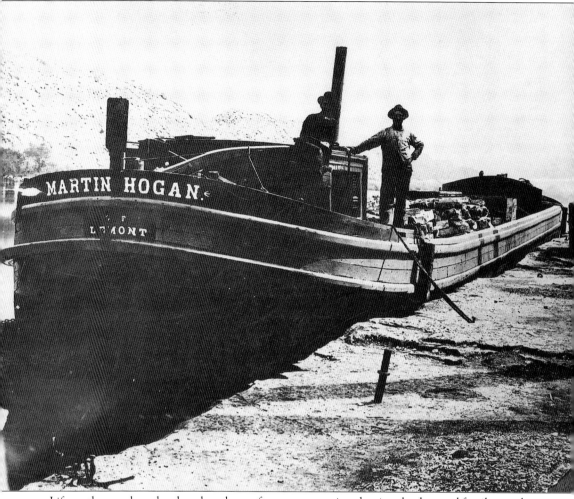

Life on the canal was hard work and was often an occupation that involved several family members. A typical extended family engaged in the canal boat business might include a father, mother, brothers, sisters, spouses, and young children. Young men might start out as mule drivers, then become steersmen, and eventually pilots or captains. At the turn of the century, the usefulness of the canal as a link to Lake Michigan and the Illinois watershed dissolved and so did this form of labor on the canal. This c. 1905 photograph shows the stone boat *Martin Hogan*. (Courtesy of Lewis University Special Collections.)

ON THE COVER: The village of Seneca is located in eastern LaSalle County and was initially known as "Crotty Town" after its founder Jeremiah Crotty. In 1857, Crotty constructed an elevator along the south bank of the canal for D.C. Underhill, which was later known as the South Elevator. By the late 19th century, Seneca was a prominent center of the grain trade along the Illinois and Michigan Canal and had several grain elevators in operation. This c. 1900 photograph shows the steamboat *Nashota* tied up at the South Elevator in Seneca. (Courtesy of Lewis University Special Collections.)

IMAGES *of America*

ILLINOIS AND MICHIGAN CANAL

David A. Belden

Copyright © 2012 by David A. Belden
ISBN 978-0-7385-8297-9

Published by Arcadia Publishing
Charleston, South Carolina

Printed in the United States of America

Library of Congress Control Number: 2011939729

For all general information, please contact Arcadia Publishing:
Telephone 843-853-2070
Fax 843-853-0044
E-mail sales@arcadiapublishing.com
For customer service and orders:
Toll-Free 1-888-313-2665

Visit us on the Internet at www.arcadiapublishing.com

> "No place is a place until the things that happened in it are remembered in history, yarns, legends, or monuments," wrote Wallace Stegner in Where the Bluebird Sings to the Lemonade Springs. Photographs are one piece to help remember a place and what happened in the past. It is important for us to remember that all history is local, and every place is a universe unto itself.

Contents

Acknowledgments		6
Introduction		7
1.	Cook County	9
2.	Will County	19
3.	Grundy County	45
4.	LaSalle County	69
5.	Sanitary Ship Canal and Illinois Waterway	89
6.	Civilian Conservation Corps	115
Bibliography		126
Index		127

Acknowledgments

The publication of this book would not have been possible without the assistance and support of Ana B. Koval, president/CEO of the Canal Corridor Association, and John M. Lamb, director of the Canal and Regional History Collection at Lewis University. Area historical repositories and residents have also provided help, support, and material from their collections for this book: Will County Historical Society, Kim Shehorn-Martin (Joliet Historical Museum), Donna Sroczynski (president of Grundy County Historical Society), Floyd Mansberger (Fever River Research), Harry Klinkhamer (Forest Preserve District of Will County), Michele Micetich (curator at the Carbon Hill Historical Society), Tricia Kelly (Hegeler Carus Foundation), Erwin Klopfstein, Dave Zelinski, Minooka Community High School, Robert Williams, Stephanie Ledesma, Dave DiLorenzo, and Sherry Harris.

Unless otherwise noted, all images in this book appear courtesy of the Canal and Regional History Collection at Lewis University.

Several people have also been helpful with local histories, materials, equipment, and expertise, and I am very grateful to those individuals: Les Kern, Debbie Dobson, and Glenda Smith (Minooka Community High School), Jennifer Butler (Lewis University Library), Robert Pruter (I&M Canal Collection archivist), Amanda Allen (for helping choose the cover image), and historian Ron Vasile (for his guidance and canal history fact checking).

I would also like to especially thank Mary Ann Atkins for her time, assistance, and friendship in providing material, images, and guidance on this project. As the digital collections librarian at Lewis University, this book would not be possible without her help and dedication. The digitization of material for this book would not have been possible without the generosity of EcoLab, Joliet Plant. A special thank-you to local photographer Joe Balynas, who provided numerous contemporary images of the canal for this publication. And a very special thank-you to Christine O'Brien for providing her time, help, expertise, encouragement, and friendship in helping to proofread the text for this book.

The production and preparation of the material for this book would never have been possible without the dedication of numerous students in my local history classes. I wish to thank Elizabeth Adcox, Grant Barker, Tyler Bryce, Annie Butterbach, Claire Campbell, Mackenzie Denoyer, Danyelle Dixon, Jacob Fleischauer, Vanessa Garcia, Hailee Goodale, Mark Harkey, Chase Hermann, Kelli Holstine, Cody Kern, Adele Kingma, James Lee, Mary Levis, Danielle Maldonado, Connor Maloney, Haley McNamara, Benjamin Miller, Kelly Mitchell, John Morrison, Bridget Pazely, Bryanna Pena, Kevin Pinkerton, Alexandra Porcaro, Elizabeth Schrishuhn, Dominic Trivisonno, Faith Trivisonno, Kaitlyn Weteska, Kimber Winchester, and Chelsea Bestow. A very special thank-you to Kylie Robey for her organizational skills and image selections, which helped make this book possible.

Finally, I acknowledge the help of John Pearson and Jeff Ruetsche at Arcadia Publishing, my wife, Krystyna, and my late grandmother Mary, who sparked my early interest in history all those many years ago.

INTRODUCTION

The years between 1800 and 1850 have been characterized as the Canal Era in US history. Since the birth of the new nation, American leaders had recognized the urgent need for a network of "internal improvements" to ease the problem of continental transportation. The success of the Erie Canal, completed in 1825, marked a period of intensive canal building in the United States. This chapter in our nation's history has been largely overlooked. Transporting people and goods by water and using animals for power dates back thousands of years, while the iron horse represented a quantum leap in technology. As a result, most historians have focused on the railroads as the prime force behind America's economic development.

While virtually unknown outside of its home state, the Illinois and Michigan (I&M) Canal is one of the most significant stories in Illinois history and in the history of transportation in the United States. Joining the waters of the Illinois River with those of Lake Michigan, the canal opened the floodgates for the development of northeastern Illinois, especially Chicago. In a time when water was still the primary method of travel, the canal connected the two great water highways of the young United States: the Great Lakes and the Mississippi River. In the process, it helped make Chicago one of the fastest growing cities in the world.

An integral part of Henry Clay's American System, the I&M Canal represented the final link in a national plan to connect different regions of the vast North American continent via waterways. The I&M Canal extended the water highway that the Erie Canal created from New York to the Great Lakes. Boats could now cross the Great Lakes to Chicago and take the I&M Canal to LaSalle where it joined the Illinois River, which in turn fed the Mississippi River south to the Gulf of Mexico. The I&M made shipping possible all the way from New York to New Orleans and made Chicago the nation's greatest inland port.

In 1827, the federal government gave the state of Illinois nearly 300,000 acres of prime farmland, the sale of which would finance construction of a canal. The I&M Canal shares with the Wabash Canal in neighboring Indiana the distinction of being the first American canals to receive federal land grants toward financing. This precedent is of great historical interest, as it later served as the model for the first federal land grant to support a railroad—the Illinois Central Railroad.

Much of the good work done by the canal occurred before it ever opened. The prospect of the canal brought people and eastern capital to what had been a lonely military outpost situated in a swampy region. The I&M Canal commissioners were also responsible for the development of a number of towns along the proposed waterway, including Chicago, Ottawa, Lockport, Morris, and LaSalle. Construction of the I&M Canal and the sale of canal lands brought thousands of people streaming into northeastern Illinois in the mid- to late 1830s, many of them Irish, German, and Scandinavian immigrants seeking their fortune on the frontier.

The canal story is also one with international implications. In 1845, with construction of the I&M Canal stalled because the state of Illinois was near bankruptcy, investors from England and France put up $1.6 million to complete the canal. The investors were not disappointed in their returns, and the I&M is one of the few American canals to have more than paid for itself.

When it opened in April 1848, canal boats pulled by mules shipped grain, coal, limestone, lumber, and hundreds of other commodities. A distinctive canal culture emerged, replete

with boat captains and crew, locktenders, toll collectors, teenaged mule drivers, and other colorful characters.

The I&M Canal's influence reached its peak during the years 1848–1852 when the canal had no serious rival as a major artery of commerce in northeastern Illinois. While the I&M had only five years free of competition with the railroads, competition from the canal forced railroads to lower freight rates on bulk goods, to the benefit of consumers everywhere. The canal was also seen as a more democratic form of commerce, as anyone with the means could register a boat and do business on the canal, whereas the railroads were a monopoly.

With the exception of the Erie Canal, only the I&M Canal opened up a water transportation corridor still viable today in the form of the Sanitary and Ship Canal and the Illinois Waterway, which eventually supplanted the I&M Canal in 1933. This is still an important artery of commerce for Illinois and the nation.

The results of the canal in the Midwest were profound. Farmers now had a reliable way to get their crops to market, thus allowing them to open up new acreage for cultivation. The digging of limestone, coal, sand, and gravel shifted into high gear, as the canal made it economically feasible to quarry and ship large quantities to fast growing Chicago. Exploiting these natural resources in turn spurred new industries, especially the manufacture of glass, bricks, hydraulic cement, and zinc.

By 1853, the Chicago & Rock Island Railroad paralleled the canal, ending the brief but colorful days of the I&M Canal packet (passenger) boat. Many people mistakenly believe that the railroads ended trade on the I&M Canal. Beginning in 1848, the I&M operated for 85 years, although the last 33 were a time of steady decline.

The canal again made headlines in 1871. Chicago's drinking water had become increasingly contaminated because of the city's rapid growth. To resolve this crisis, the I&M Canal was deepened to reverse the river and carry the sewage and filth away from Lake Michigan. In 1871, a few months before the Great Chicago Fire, the Deep Cut was completed and at least temporarily improved the city's health. In 1900, the Chicago Sanitary and Ship Canal opened to complete the job begun by the I&M.

By 1933, larger manmade waterways, the railroad, and highways had eclipsed the I&M Canal's role as a commercial thoroughfare. Civilian Conservation Corps (CCC) workers built a canal trail, but government officials overlooked the canal in the following years, and it fell into disrepair. In the 1950s, the canal bed provided a convenient right-of-way for the Stevenson Expressway. Today, the Illinois and Michigan Canal National Heritage Corridor, a new kind of national park, welcomes travelers to the parks, trails, canal towns, and landmarks along this historic passageway.

Given its importance, relatively few photographs of the canal exist from its opening in 1848 until roughly 1870. No photographs exist showing the construction of the canal, which took 12 long years. Nor are their photographs showing the operation of the canal packet boats, which carried tens of thousands of passengers during the first five years of the canal's existence. Most photographs of the canal in operation were taken long after its glory had faded.

Fortunately, David Belden has tracked down a number of significant images documenting the history of the canal, and his text highlights all of the important phases of the canal's history as well as the communities along its path. Many of these are from the Lewis University Canal and Regional History Collection archives.

—Ron Vasile, I&M Canal historian

One

Cook County

In 1673, French explorers Jacques Marquette and Louis Jolliet were the first to recognize the importance of the portage near Chicago as a potential water link between the Great Lakes and the Mississippi River. Jolliet believed a canal cutting through a half a league of prairie from the foot of Lake Michigan to the Des Plaines River could help to build a trading and commercial empire for France.

In spite of the lack of interest on the part of the French to settle or construct a canal in the 18th century, the young United States government did establish Fort Dearborn in 1803 to protect the mouth of the Chicago River and the land and trading posts around it. Within a few years, the idea for a canal in the region reappeared, gaining momentum after the War of 1812 when the Treaty of St. Louis was signed in 1816. This treaty ceded land directly southwest from points 10 miles north to 10 miles south of the mouth of the Chicago River. With this boundary line dividing the land between the Native Americans and the white settlers, the federal government acquired control over the Chicago River corridor linking Lake Michigan and the Mississippi River.

Soon, initial surveys for the canal route were conducted, funds were raised, treaties were signed, and land was auctioned along the route to help finance the project. Ground was broken and canal construction began in earnest on July 4, 1836, only to be thwarted by a series of financial problems lasting seven years. The canal was finished in 1848, only after a financial and administrative reorganization. Construction costs for building the canal reached nearly $6.5 million, and the project employed thousands of Irish immigrants (hired by contractors) who worked and lived in transient work camps along the 96-mile-long route.

Once completed, the I&M Canal route stretched from the south branch of the Chicago River to the Illinois River at LaSalle and included 15 locks, a pumping station, two summit-level locks, four feeder canals, and four aqueducts. The construction of the Sanitary and Ship Canal and the Illinois Waterway, major engineering achievements in the 19th and 20th century, would eventually lead to the demise of the I&M Canal by 1933.

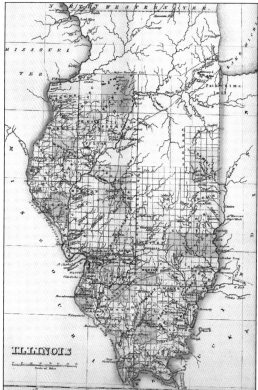

On their return trip up the Illinois and Des Plaines Rivers in 1673, Louis Jolliet and Jacques Marquette discovered the watershed that would soon be called the Chicago Portage. Jolliet understood that a canal through the portage could help to build a trading and commercial empire for France. This J. Yeager map of Illinois was first published as *Carey and Lea American Atlas of 1823*. The map suggests the idea of a canal route connecting the Chicago River with the Des Plaines River.

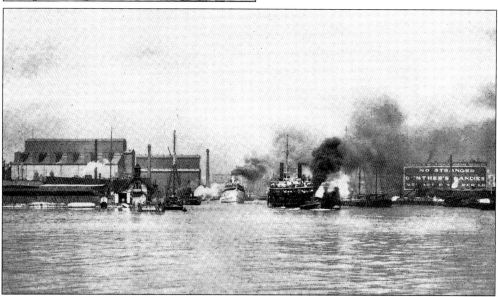

Early traders and settlers who came to the region understood the importance of the Chicago River and quickly distinguished the river's two main branches, which flowed north and south. Once the river was connected to the Illinois River by way of the I&M Canal, the commercial value of the waterway was enhanced, and the mouth of the Chicago River became a funnel for commerce. This late-19th-century photograph shows the crowded conditions that existed as boats entered the harbor.

Shortly after early settlement, the south branch of the Chicago River was known as the River of the Portage, as it became the key link between the Great Lakes and the Mississippi River. This branch of the river flowed southwest from a swampy location (above) called Mud Lake by early adventurers. From Mud Lake west, a small channel, known for years as the West Fork, meandered a short distance before ending. It was along these tributaries that the notion of a canal that connected the Des Plaines River to the Chicago River was first contemplated. Louis Jolliet, a French Canadian explorer and cartographer, and Father Jacques Marquette were the first to suggest the idea of digging a canal to bridge these waterways in 1673. The canal (below) following the route was finally realized in the 19th century, when construction began on the I&M Canal in 1836. (Both, courtesy Joe Balynas.)

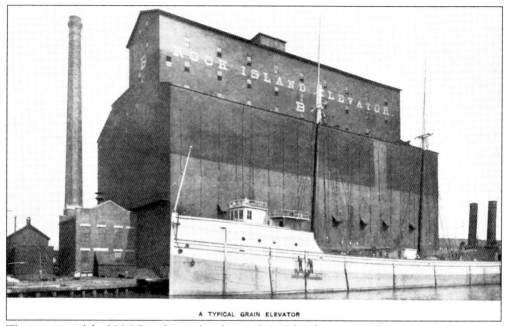

A TYPICAL GRAIN ELEVATOR

The opening of the I&M Canal stimulated agricultural development in the region and generated the growth of new business enterprises tied to agriculture. As towns formed along the canal route, farmers settled in the area and helped spur the economic growth of the Illinois River Valley. The efficiency of Chicago's grain elevators, such as the Rock Island Elevator (pictured in the c. 1890 photograph above), allowed the city to compete successfully with St. Louis, where grain was loaded in sacks by hand. The settlement patterns of the area also increased the demand for lumber in the region. The I&M Canal allowed for lumber from Michigan and Wisconsin to be easily processed and shipped on water to markets south, east, and west of Chicago. The c. 1900 image below shows a schooner docked along a wharf on the Chicago River where lumber is stored and loaded for transport.

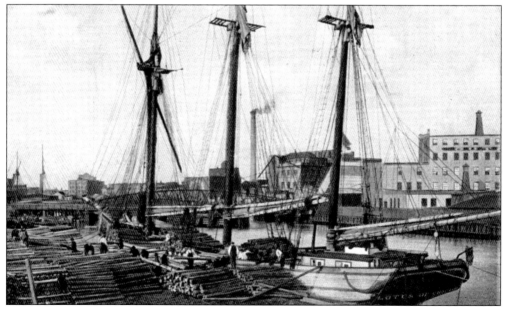

The eastern end of the I&M Canal was located in the town of Bridgeport. While little remains of the canal in the location, small remnants can still be found in the area. The old turning basin (above) near the 2800 block of South Ashland Avenue where the South Branch of the Chicago River joins the Sanitary and Ship Canal is still visible. To the right and not in view in this photograph is the southern fork of the South Branch, known as Bubbly Creek. Bridgeport was home to the Chicago Union Stock Yards and the big "disassembly" factories of Swift, Armour, and Morris. Chicago's notorious Bubbly Creek is where the stockyards once discarded their offal into the river, and water bubbled because the material on the bottom was decomposing. The photograph below shows another view of the turning basin looking west. (Both, courtesy Joe Balynas.)

The original plans for the I&M Canal construction called for a cut through the limestone bedrock at the summit. Because of financial issues, modifications to the original canal construction plans were made, and summit locks were constructed instead. After the I&M Canal was deepened in 1871, a new lock and pumping station were located to the west of Ashland Avenue. This photograph shows the corner of Lock and Fuller Streets today, just east of the old lock and pumping station. (Courtesy Joe Balynas.)

Opening on Christmas Day 1865, the Union Stock Yards covered a 475-acre area west of Halsted Street between Thirty-ninth and Forty-seventh Streets. The stockyards were located near a fork of the South Branch of the Chicago River not far from the I&M Canal. Water was pumped into the yards daily, and waste was drained into the river. Once the refrigerated trucks and highways came into play, the plants moved west, and the Union Stock Yard and Transit closed forever in 1971. (Author.)

Fr. Jacques Marquette was a Jesuit missionary who traveled with Louis Jolliet on an expedition to explore the Mississippi River in 1673. Marquette returned to the Chicago region in 1674–1675 on missionary work and remained during the winter because he was too ill to travel to Kaskaskia. According to his diaries, Marquette stayed along the South Branch of the Chicago River near the eastern end of the Chicago Portage and reflected on the importance of the river and Lake Michigan on the area's landscape. Over the years, efforts have been made to memorialize the site, including a mahogany cross that was erected on September 28, 1907, by the City of Chicago, the Chicago Association of Commerce, and Valentine Smith, the city archivist. In 1930, the City of Chicago also honored Marquette on a bronze tablet that is located on the northern bridge tower of the Damen Avenue (Robey Street) Bridge. (Both, author.)

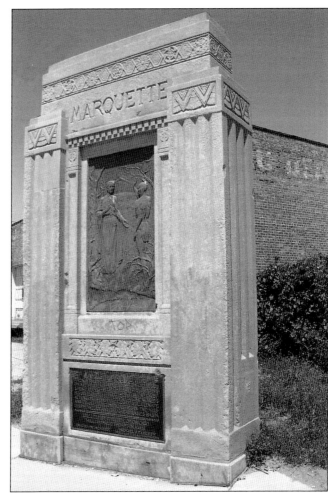

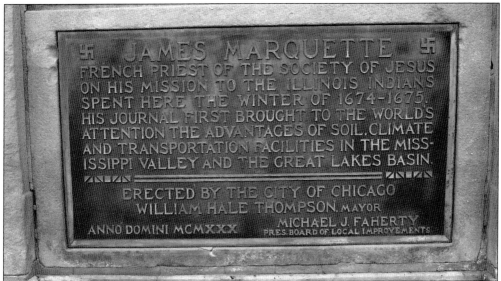

Creating connections between different bodies of water has always involved a challenge, especially to 17th- and 18th-century explorers. Such connections often involved portages, or the carrying of boats, supplies, and equipment between navigable waters. Locally, portages existed between the Calumet and Kankakee Rivers and between the Des Plaines and Chicago Rivers. The most notable portage exists nearly 10 miles west of Lake Michigan in Lyons on a natural subcontinental drainage divide, which has become known as the Chicago Portage. (Courtesy Joe Balynas.)

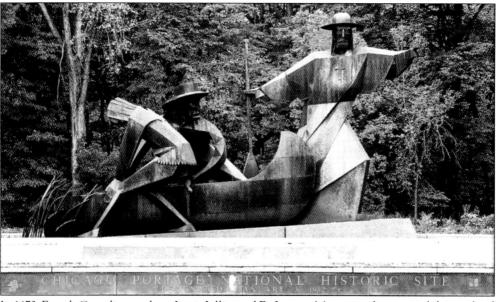

In 1673, French Canadian explorer Louis Jolliet and Fr. Jacques Marquette first crossed this wetland area on their return trip from the exploration of the Mississippi Valley. This area stretches nearly six miles and was quickly recognized by Jolliet for its strategic value, namely, providing a critical link between the Chicago and Des Plaines Rivers. Jolliet suggested to his patrons at Quebec that by cutting a canal through the "river portage," New France could control the water route through the interior of the continent. (Courtesy Joe Balynas.)

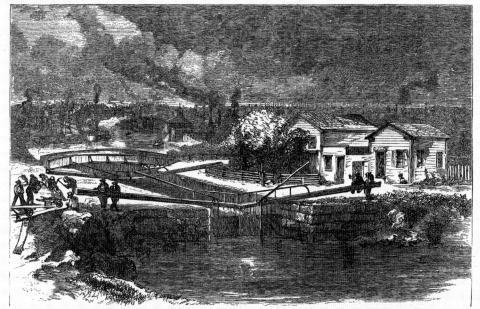

To compensate for the 141-foot drop in elevation from Lake Michigan to the Illinois River at LaSalle, a series of canal locks, or "water elevators," were necessary at various locations to lift boats over the change in elevation. Originally, there were 17 locks on the canal, but the Deep Cut project of 1871 eliminated the two summit locks, one at Bridgeport where the canal separated from the Chicago River, and the other several miles north of Lockport. This c. 1871 lithograph appeared in Harper's Weekly and shows the summit Lock No. 1 at Bridgeport.

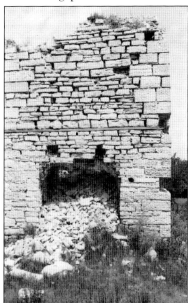

During the 19th century, building stone in northern Illinois was primarily quarried in Lemont, Joliet, and Chicago. Limestone was commonly used in architecture, as it was relatively easy to cut into blocks or more elaborate carvings. Because the heating of limestone allowed for the production of a marketable material, lime kilns were constructed in many locations in Illinois, including waterways. This c. 1974 photograph shows the remains of a kiln along the I&M Canal in Lemont.

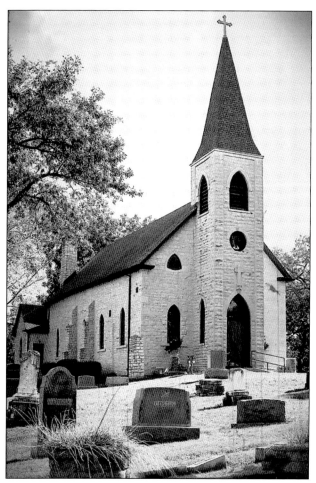

The construction of the I&M Canal provided an opportunity for many Irish immigrants to settle along the canal corridor and find employment with local contractors. Many of these immigrants arrived with few skills and little education, and frequently performed the harshest manual labor on the canal, often digging by hand. Those who did not die from exhaustion, malaria, or other waterborne illnesses settled in communities that sprang up along the new canal. Because many Irish were Roman Catholic, they soon helped to erect churches and cemeteries within the canal corridor. Located on a high ridge near the I&M Canal in Lemont, St. James of the Sag is one of the oldest functioning Roman Catholic churches in the Chicago area and contains graves of Irish laborers who perished while digging the Illinois and Michigan Canal. St. James Catholic Church and Cemetery, shown in these photographs, was listed in the National Register of Historic Places in 1984. (Both, courtesy Joe Balynas.)

Two

WILL COUNTY

The first people known to have lived in Will County are now known as the Mound Builders. These Native Americans are known for constructing mounds of earth for burying their dead. At one time, these mounds were found all around Will County. The Potawatomi Indians were the last group of Native Americans to live in this area. In the early 19th century, it is estimated that nearly 3,000 Potawatomi lived in what is now Will County.

Beginning in 1673, European explorers traveled through the area. Early French explorers Louis Jolliet, Fr. Jacques Marquette, and Robert Cavalier Sieur de La Salle recognized the value of the region for commerce and transportation. Jolliet believed a canal cutting through a half a league of prairie from the foot of Lake Michigan to the Des Plaines River could help to build a trading and commercial empire for France.

Soon, French fur traders began to take advantage of the abundance of animals available for trapping; in time, a lucrative fur-trading industry was established in the region. By the 1820s, the fur trade waned as the population expanded. In 1826, Jesse Walker established the area's first permanent white settlement, Walker's Grove, near the present town of Plainfield. Within a decade, the early settlers petitioned for separation from Cook County and formed Will County.

During the early years from the settlement of the region until 1850, several important developments helped to shape the future of the county. The Des Plaines River provided an early water highway for travel as well as a source of power, which gave rise to mills and manufacturing in the area. Formed thousands of years ago during the last ice age, the limestone rock beds provided the bedrock to help build a 19th-century city.

Most important to the history of Will County was the development of a transportation network. From the opening of the I&M Canal in 1848 to the building of the Illinois Central and Rock Island Railroads in the 1850s, Lockport and Joliet became important hubs between rural towns in Will and Grundy Counties and Chicago. It is not hard to understand why the agriculture and livestock success of the county can be directly linked to the dependence upon the I&M Canal and the railroads.

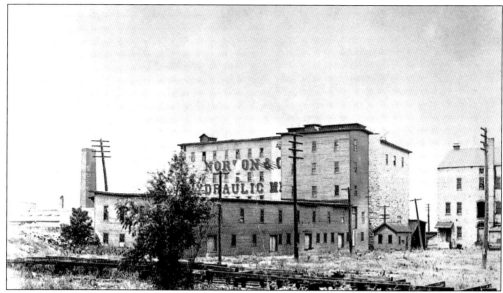

Hiram Norton was one of many East Coast businessmen who moved to the area and recognized the great potential the canal would bring to the region. In addition to the warehouse on the south end of the landing, Norton built a flour mill, a paper mill, and various assorted support facilities in the Hydraulic Basin. The water-powered Hydraulic Basin was built for milling flour and making a variety of paper and wood products. Norton and Company prospered until it experienced financial problems related to the nationwide economic depression of 1893 and the demise of the I&M Canal in the early 20th century. Looking west, the c. 1912 photograph above shows the Norton Flour Mill in the Hydraulic Basin. The c. 1895 photograph below shows the extent of the Norton operations associated within the Hydraulic Basin.

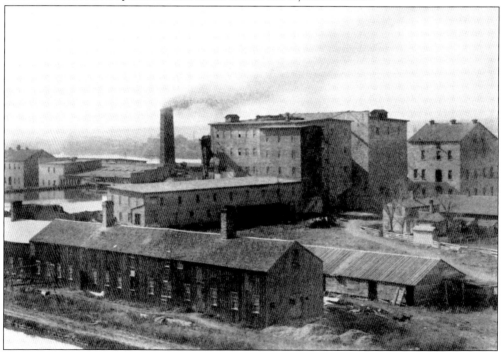

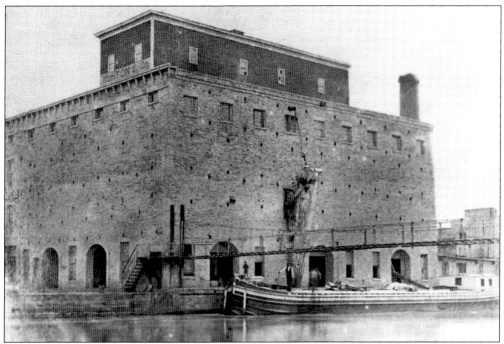

Located at 10th Street and the I&M Canal, the Norton Warehouse dominated the south landing and was a cornerstone of the Lockport economy for nearly 50 years. During this time, Norton and Company functioned as Lockport's major employer and helped to establish the town as an important agricultural center. Using locally quarried limestone in the early 1850s, Hiram Norton constructed a three-and-a-half-story grain storage complex nestled on the east banks of the canal. The western side of the warehouse had three arched portals, which allowed goods to be moved in and out of the building directly from the docked canal boats. The c. 1869 photograph above shows the Norton Building looking east across the I&M Canal. The c. 1905 photograph below shows a view of the warehouse and elevator looking south across the Chicago & Alton Railroad tracks.

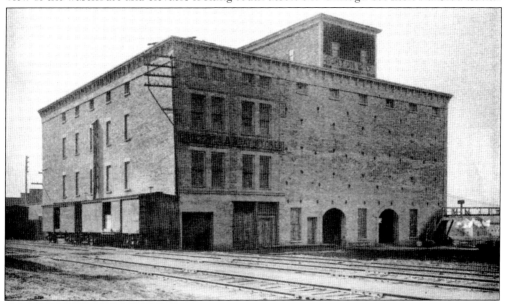

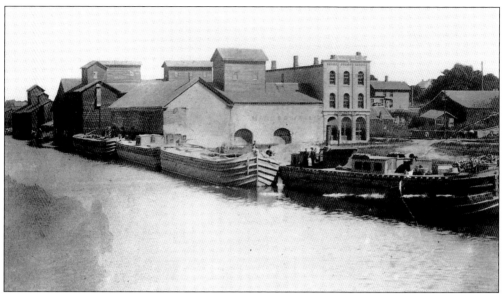

At the north end of the public landing and bordering the I&M Canal on the east bank is the Gaylord Building. Constructed in 1838, the one-and-a-half-story limestone structure first functioned as a supply depot, mule barn, and warehouse. In 1853, George Martin purchased the building for use as a grain warehouse. By the early 1860s, Martin added a three-story building to the east side of the structure for additional storage and office space. Different individuals have owned and occupied the building over the years, including Hiram Norton, the Barrows Lock Company, and the Hyland Plumbing Supply Company. Today, the Gaylord Building is one of 28 National Trust Historic Sites and is listed in the National Register of Historic Places. The above image shows a view of the Gaylord Building from the west side of the canal around 1880. The bottom image shows the Gaylord Building today. (Below, courtesy Joe Balynas.)

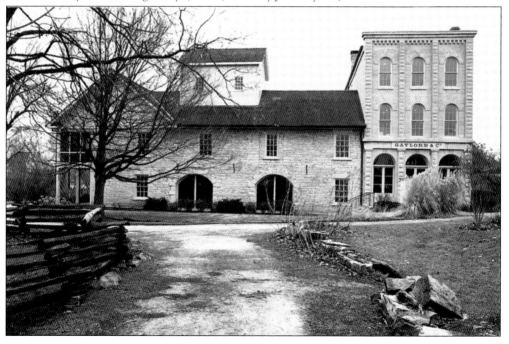

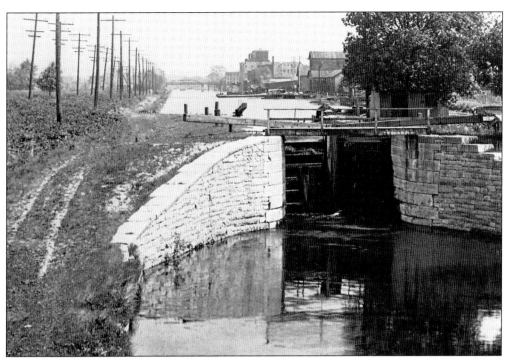

The construction of the I&M Canal helped to extend the water highway that the Erie Canal created from New York to the Great Lakes in 1825. When it opened in 1848, the I&M Canal provided the last link to connect the Eastern Seaboard with the Mississippi River. Canal boats could now navigate the Great Lakes from Buffalo to Chicago and then take the I&M Canal to LaSalle, follow the Illinois River to the Mississippi, and travel south to the Gulf of Mexico. Construction of the canal began in 1836 under the direction of William Gooding. The photograph above shows a view of Lock No. 1 and the change in elevation looking north toward Chicago. The photograph below shows the canal through Lockport, looking south near the Norton Building. The canal was 120 feet wide at this point to exploit the use of hydraulic power created by the canal and to accommodate boat traffic.

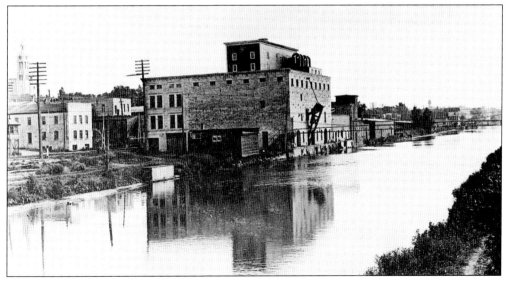

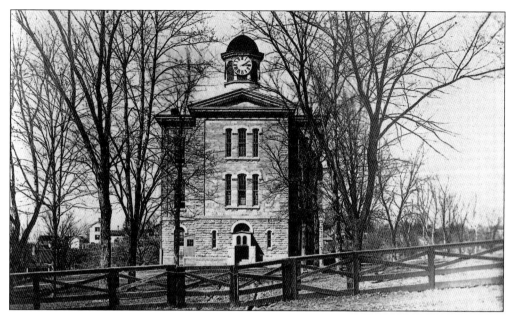

In 1857, a three-story stone schoolhouse designed by architect Julius Scheibe was erected on the Central Square in Lockport. The building burned in the 1895 fire and was replaced the following year with a handsome, three-story Romanesque structure. The new school building was constructed from native limestone by architect John Barnes of Joliet. The school, which served the educational needs of the community for nearly 70 years, was considered highly innovative for the 1890s because the architectural plans placed such emphasis on large interior spaces with many big windows to let in light and air. Today, the old school building serves as the Lockport Township government offices. The postcard photograph above shows a view of the 1857 school on the Central Square, and the postcard below shows the 1897 structure.

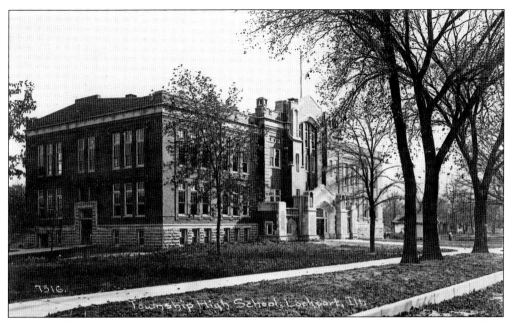

Lockport, Illinois, is a town rich in history, with the first settlers arriving in the area in 1830. Soon after settlers arrived, school classes began in a log cabin on what is now Division Street. The first village school was built in 1857 and housed students of all ages. The three-story building was constructed of limestone quarried locally and had a four-sided clock tower on its roof. The first graduation was held June 28, 1888. Construction of a new high school on South Jefferson Street was started in 1909, and the school opened a year later. Since it opened, there have been two major additions made to the building in 1930 and 1953. The high school now occupies the entire block of Twelfth, Jefferson, Thirteenth, and Madison Streets. The postcard photograph above shows the high school campus in 1910, and the postcard below shows the main entrance to the high school.

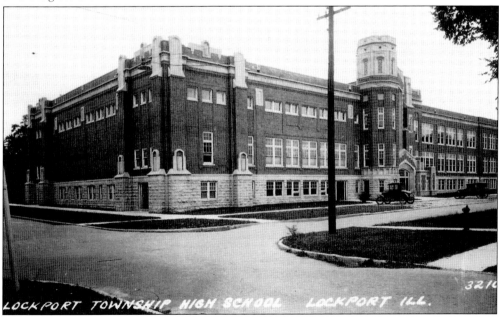

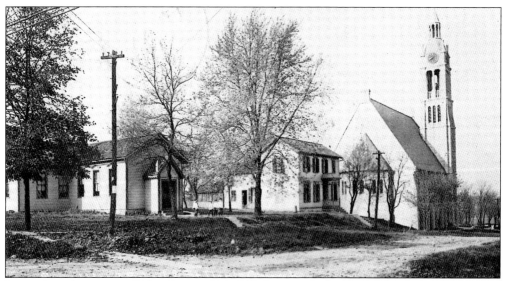

Located on the corner of Hamilton and Twelfth Streets, the impressive limestone church was designed by Egan and Hill, architects for the Archdiocese of Chicago, and constructed in 1877. Founded in 1846 by Fr. Dennis Ryan, the parish originally served the Irish community and its canal workers, who made up the first congregation. The large 170-foot steeple of St. Dennis Catholic Church is a prominent architectural feature that is visible along the eastern bluff of the Des Plaines River.

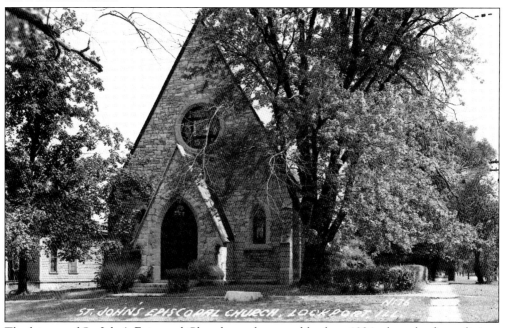

The history of St. John's Episcopal Church can be traced back to 1834 when the first religious services were held. In 1844, an oak-frame church was built several blocks east of the Illinois and Michigan Canal. This church was replaced in 1870 by a limestone building designed by local architect P.N. Hartwell. Located on the southeast corner of Eleventh and Washington Streets, the church is shown in this picture postcard view looking east. Today, the church continues to serve the community of Lockport and is in the midst of a major building and expansion project.

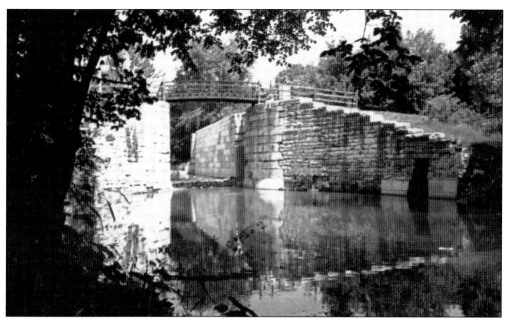

The I&M Canal changed the nation when it opened in 1848 and provided the last link in a chain of waterways that connected the Eastern Seaboard with the Mississippi River System. The I&M Canal was nearly 100 miles long and ran from Chicago to LaSalle, and the 15 locks (originally 17) in the system created a "water ladder" that allowed boats to climb up or down the change in elevation between the Chicago and Illinois Rivers. The creation of the Illinois Waterway in 1933 helped to create a modern deepwater link between the Great Lakes and the Gulf of Mexico. The Illinois Waterway uses the Des Plaines, Illinois, and Mississippi Rivers to help make the link from Chicago to New Orleans. The photograph above shows Lock No. 1 on the old I&M Canal in Lockport, and the photograph below shows a modern lock on the Illinois Waterway in Lockport.

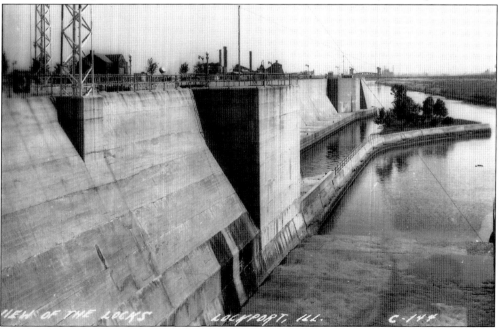

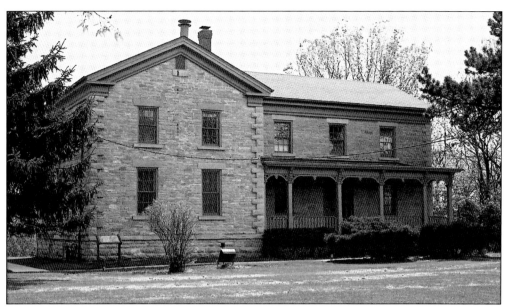

Patrick Fitzpatrick was an Irish immigrant who arrived in Lockport in the early 1830s before the construction of the Illinois and Michigan Canal. In 1842, Fitzpatrick constructed a T-shaped limestone farmhouse on a bluff adjacent to an early Indian trace. The details of the homestead are typical of the Greek Revival style favored by many before the Civil War. Acquired by Lewis University in 2001, the Fitzpatrick House is a Will County landmark and is listed in the National Register of Historic Places. (Courtesy Joe Balynas.)

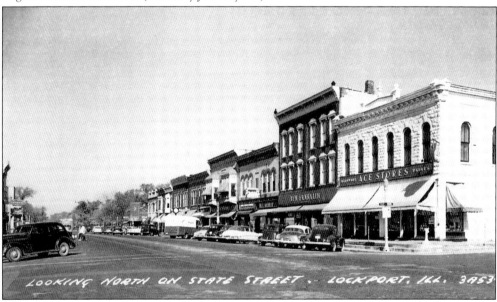

With a few exceptions, State Street today remains intact, and the streetscape is well preserved. State Street is also a major part of a National Register Historic District, which extends between Seventh and Eleventh Streets and from Canal Street to Washington Street. The east side of the block, except the old Norton Store building, was burned in the 1895 fire and completely rebuilt within a few months' time. This photograph shows a view of State Street looking north from Tenth Street in the 1940s.

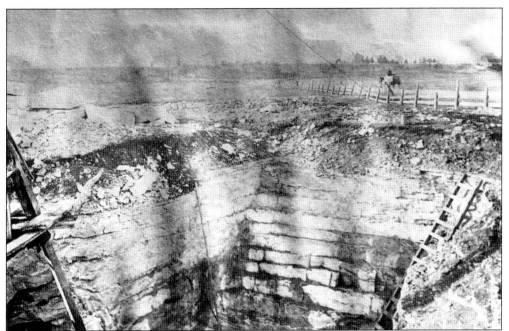

Dolomitic limestone underlays sections of northern Illinois, and quarries are often located where thick stone deposits occur near the surface. In the canal corridor, the largest concentration can be found in an area from Joliet to Lemont. The towns of Joliet, Lockport, and Lemont all became the centers of 19th-century quarrying activity. Limestone blocks were used for foundations, bridge abutments, aqueduct piers, and lock walls. Most stone used along the canal was quarried just north of Joliet, but two other tracts in Aux Sable and Ottawa were also utilized. The c. 1891 photograph above shows a 19th-century quarry hole near the Des Plaines River in Lockport. The c. 1897 photograph below shows quarry workers cutting and cracking the stone.

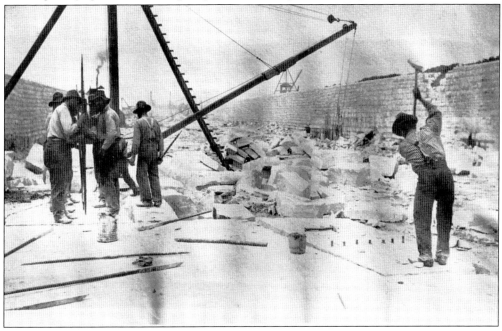

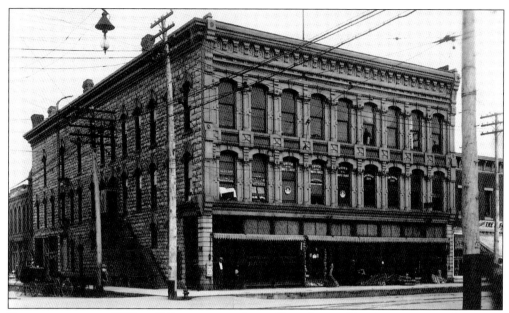

Young entrepreneur William F. Barrett opened a small tin shop and hardware store on the corner of Bluff and Jefferson Streets two years after the I&M Canal opened. As his business grew, Barrett moved several blocks east to the Akin Block on Jefferson Street. By the early 1880s, Barrett's sons had joined the Barrett Hardware business, and it moved again to the newly constructed Munroe Building. Located on the southeast corner of Chicago and Clinton Streets, the three-story building was commonly known as the Barrett Block because the hardware company leased space in the building. Just before noon on Saturday, April 4, 1908, a fire broke out in the hardware store, and the entire building was in flames within minutes. The cause of the fire is still a mystery. The photograph above shows the Barrett Block Building before the fire, and the photograph below shows firefighters working on the blaze.

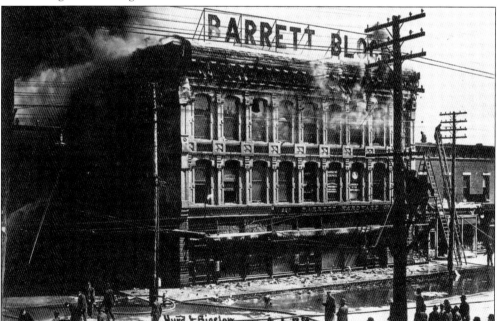

Edwin Porter moved to Joliet in 1856 and soon entered the malting and brewing business along the Des Plaines River. His first business was small, but he eventually became the largest brewer in the city and one of the largest in the state. In 1866, construction began on a three-story stone building, and an addition along South Bluff Street on the west side of the river was later added. The water for the brewing of beer, which was over 90 percent of Porter's output, was furnished from two artesian wells. The firm was incorporated in 1893, and the name was changed to E. Porter Brewing Company. It continued to operate until Prohibition doomed Porter and other Joliet breweries. The c. 1889 photograph above shows a view of the brewery operations looking across the Des Plaines River. The photograph to the right shows the facade of the old three-story building in the mid-1950s.

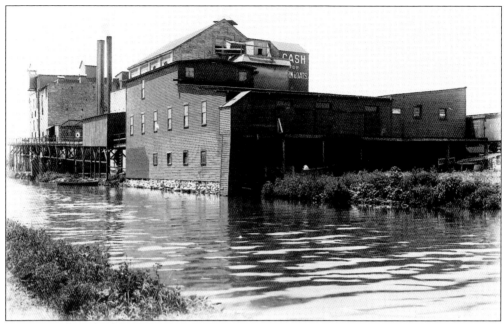

In 1856, Ferdinard Schumacher organized his German Mills American Oatmeal Factory in Akron, Ohio. His plan was to introduce steel-cut oats to the American diet at a time when oats were considered inappropriate for anything but horses. German and Irish immigrants were the first to bring the food to their tables because they were accustomed to eating oats in Europe. Oat milling in the 19th century was a relatively low-cost operation, and competitors quickly appeared as oats gained acceptance as a food staple. By the 1880s, there were established markets throughout the Midwest, especially in Chicago, Milwaukee, and Detroit. These c. 1900 photographs show views of the Oliver Oat Mill, which was located along the I&M Canal in Joliet.

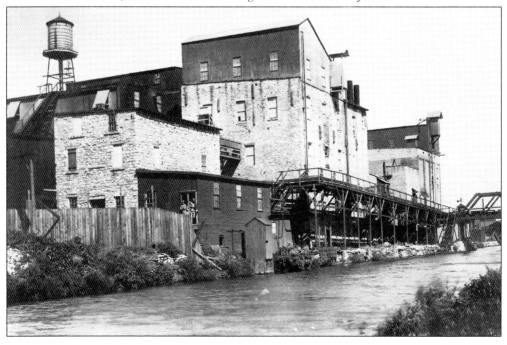

For hundreds of years, one of the most important roles of windmills has been for mechanical water pumping, especially for stock watering and farmhouse water needs. The Leach Windmill Company was established in 1871, the same year Leander Leach patented and began manufacturing his steel-blade units. Located along South Center Street and the I&M Canal in Joliet, the Leach Windmill Company (later known as the Leach Windmill and Tank Company) sold products throughout the Midwest.

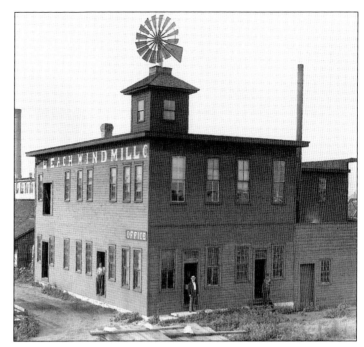

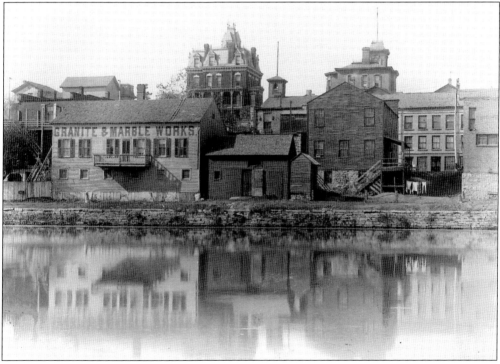

Looking across the I&M Canal, this 1880s photograph shows the west side of the canal and several businesses along Bluff Street, including the Granite & Marble Works owned by Henry A. Smith and George P. Nape. Rising above all the structures is the three-story, red brick, Second Empire–Italianate home of Hiram B. Scutt, which was constructed in 1882 on Broadway Street. Scutt was a prominent Joliet businessman who began manufacturing barbed wire in Joliet in 1874.

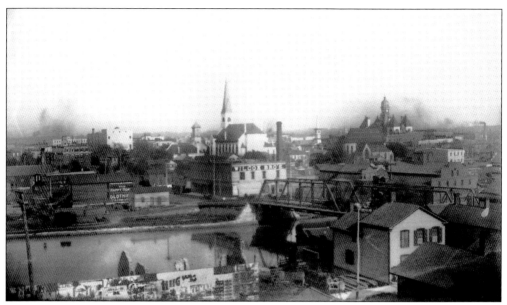

This 1880s photograph shows a view of downtown Joliet looking east across the I&M Canal. In Joliet, the Illinois and Michigan Canal ran through downtown on the west side of the Des Plaines River. In this photograph, local landmarks can be seen, including the third Will County Courthouse, St. Mary's Church, and the Cass Street Bridge. By the early 1890s, competition with the railroads and the economic downturn of 1893 affected canal operations. The last canal boat traveled through Joliet in October 1914.

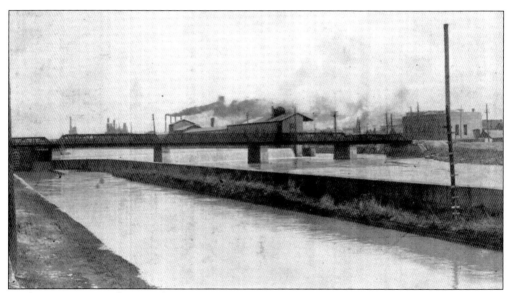

Looking west across the Des Plaines River, the Jackson Street Bridge and Dam can be seen. The photograph was taken from the Economy Light and Power Company on the east side of the river. Founded in 1890, the Economy Light and Power Company merged with other power companies to form the Public Service Company of Northern Illinois in 1911. The old Jackson Street Bridge, the dam, and the I&M Canal were cleared and removed in 1932 as part of the deepwater Illinois Waterway project.

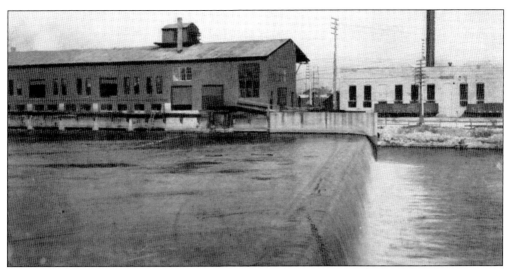

Looking east across the Des Plaines River, this photograph shows the Jackson Street Dam in the foreground and the powerhouse plant of the Economy Light and Power Company on the left. The dam produced the power needs for local consumers and helped to operate the large generators that supplied the power to the city. Missing from the photograph and just east of the powerhouse are the familiar twin steeples of the historic 1891 St. Joseph Church, located at the north end of Joliet's city center.

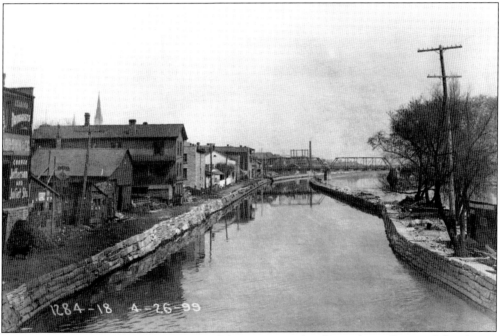

The Sanitary District of Chicago separated the I&M Canal and Des Plaines River in Joliet during the 1890s. This photograph shows the I&M Canal in the foreground and the drainage canal (Des Plaines River) in the background. The I&M Canal and locks were located along the west bank of the river, and Lock No. 5 was near the Jackson Street Bridge. The old towpath seen on the right that separated the river from the canal would be submerged in the early 1930s to make room for the new Illinois Waterway.

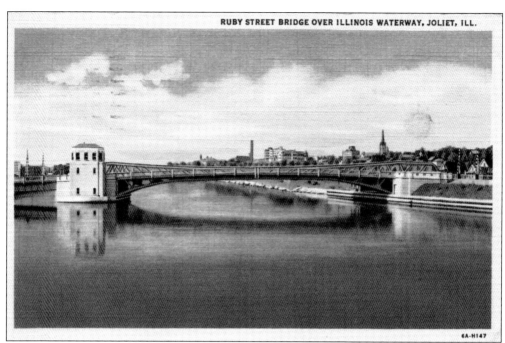

In 1892, the Sanitary District of Chicago was created. Construction began on a large canal to improve transportation and dilute waste to move it downstream. The section from the new Sanitary and Ship Canal from Chicago to Joliet was completed by 1907. Improvements to the Illinois and Des Plaines Rivers continued into the early 20th century, and the new Illinois Waterway was opened in 1933. From McDonough Street on the south to Ruby Street on the north, Joliet has six lift bridges that span across the Des Plaines River. The modern Scherzer rolling lift bridges are found at McDonough, Jefferson, Cass, and Jackson Streets. The Ruby Street Bridge (above) is a Bascule trunnion-style bridge. The Joliet Railroad Bridge is a vertical-lift truss bridge. The image below shows a large crowd assembled for the grand opening of the Jackson Street Bridge in 1932.

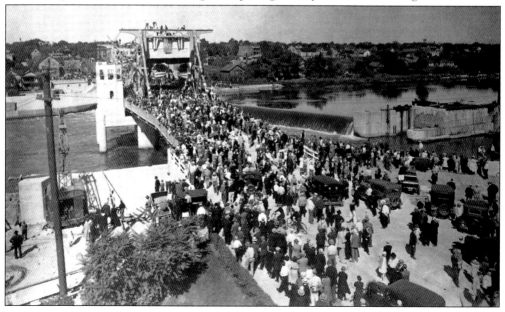

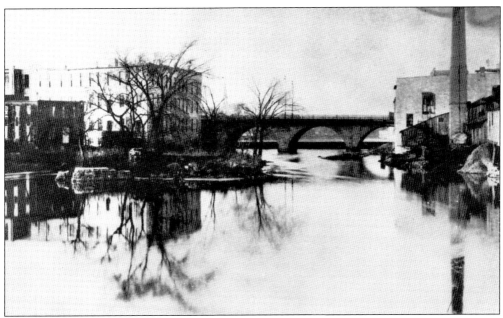

The stone arch bridge at Jefferson Street was built in 1871 and joined the east and west sides of the town. Looking south down the Des Plaines River, the c. 1885 photograph above shows the old Jefferson Street Bridge and Dam. Just north of the bridge and out of view to the right was the I&M Canal and locktender's house. The Illinois and Michigan Canal ran through Joliet on the west side of the Des Plaines River. The old Jefferson Street Bridge was destroyed by dynamite in 1898, and replaced by a Scherzer rolling lift bridge in 1932. Outside of Chicago, Joliet has the largest number of operable lift bridges in the Midwest. The Scherzer Rolling Lift Bridge Company also constructed similar bridges at McDonough, Cass, and Jackson Streets. Below is a view of the Jefferson Street Bridge today.

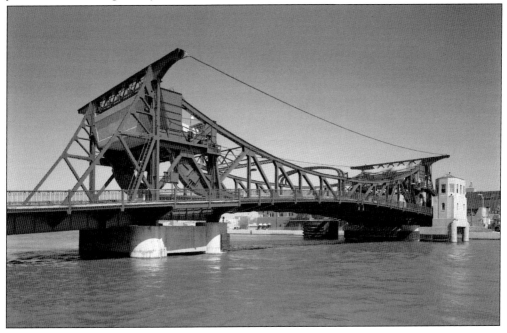

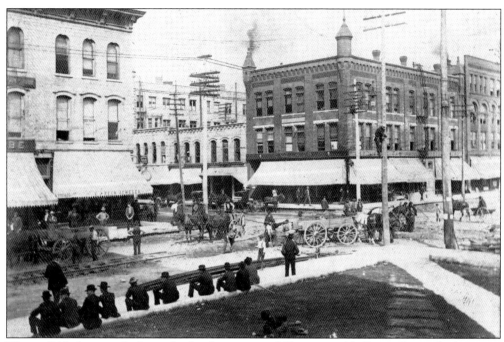
This c. 1897 photograph shows the familiar corner of Chicago and Jefferson Streets looking east from the Courthouse Square. The building on the left is the Goodspeed Building, which would be home to the Chicago Dentists for many years. Across the street on the northeast corner, the familiar three-story brick building housed the Harris and Foley store, and a portion of the Young Building is visible just down the block.

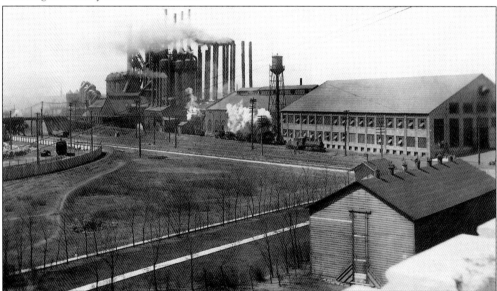
Located on the city's north side is one of the largest iron and steel manufacturing facilities in the nation. Between 1870 and 1930, the Joliet Iron and Steel Works employed thousands of Joliet-area residents, most of them immigrants who produced iron and steel products, including rails for the nation's growing railroad system. This image shows a view of the complex, including the engine house, the hot-blast stoves, and Furnaces No. 3 and No. 4.

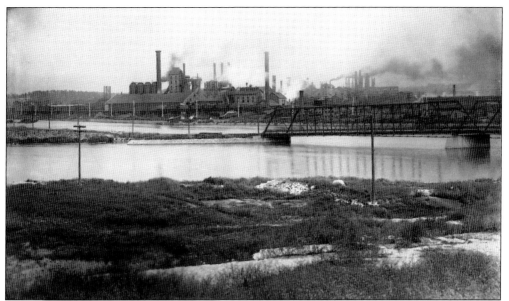

Joliet is known as the "City of Steel" because the town was a major steel-producing center for many years. In the early 1870s, the Joliet Iron and Steel Company was producing iron and steel products. The plant assumed new ownership numerous times and eventually became part of the Illinois Steel Company. This photograph of the Joliet Steel Mills shows a panoramic view of the plant complex located just north of the city between Collins Street and the Des Plaines River.

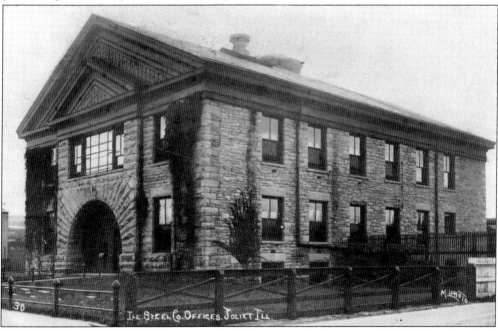

During the last part of the 19th century, the Chicago area became one of the leading centers of iron and steel production. By the end of the 1880s, the local and national mills began expanding and consolidating efforts. In 1889, one of the first great mergers occurred when most of the area mills combined to form the Illinois Steel Company. This photograph shows the Illinois Steel Company office building that was constructed in a Neoclassical Romanesque style in 1891.

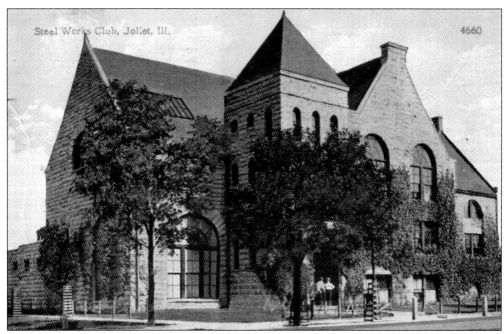

In 1889, the Illinois Steel Company built the Steel Works Club on the southeast corner of Collins and Irving Streets. The Steel Works Club was intended to serve as a social, cultural, and recreational center, and employees had many membership privileges through the club for nearly 43 years. In 1932 during the Great Depression, the Steel Works Club closed, and the building was purchased by a religious order and opened as the St. Stephen's Hungarian Chapel in 1937.

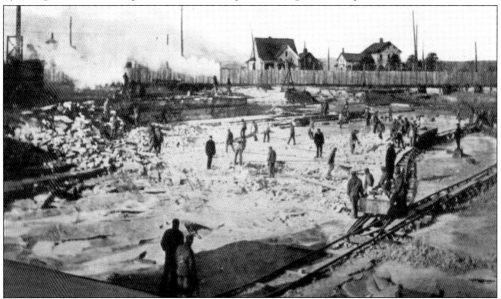

The area surrounding Joliet contains abundant supplies of limestone. Stone quarrying in the Joliet area began during the 1830s, and limestone was used locally and regionally for a variety of structures. In 1857, the state of Illinois bought 72 areas along Collins Street for a new prison. Inmates arriving from Alton Prison in 1858 began working the prison quarry under the supervision of contractors Lorenzo P. Sanger and Samuel K. Casey. The limestone quarry was used to build the prison walls and buildings.

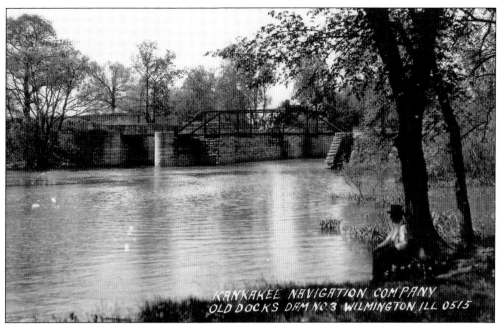

In 1871, eastern investors purchased the old charter from the Kankakee Company and created the Kankakee Navigation Company, which repaired and improved the old dam and eventually constructed five lock-and-dam combinations on the river. These locks and dams help create enough slack water in the canal basin to make the Kankakee River navigable for nearly 10 miles above Wilmington. This picture shows old Lock No. 4 near Dam No. 3 in Wilmington. (Author.)

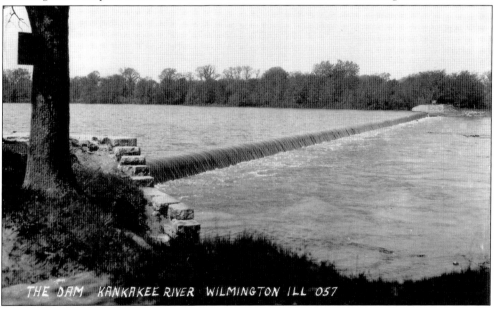

After settlement, the first individuals to utilize the Kankakee River were those who valued it as a source of power. They built dams and mills for processing grains and cutting timber. Many of the 19th-century dams were constructed from wood and did not hold up to the occasional ice jams and floods that are common on the Kankakee River. This photograph is of the Wilmington Dam (Dam No. 3) looking west across the Kankakee River. (Author.)

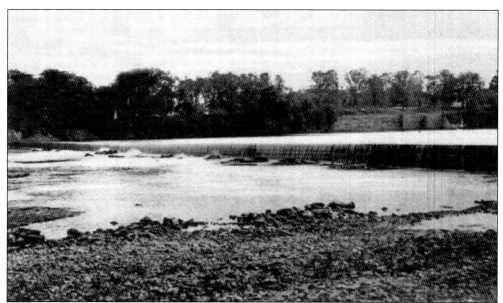

Looking east across the Kankakee River, Dam No. 3 is visible in the foreground. In the 1870s, the Kankakee Navigation Company built a series of dams and locks along the Kankakee River to help make the river from the Indiana border to the I&M Canal navigable by boat. Directly behind the dam in the distance, the remains of old Lock No. 4 are visible. Lock No. 4 was constructed at the foot of Alden's Island and allowed prospective investors along the millrace to generate waterpower for their needs. (Author.)

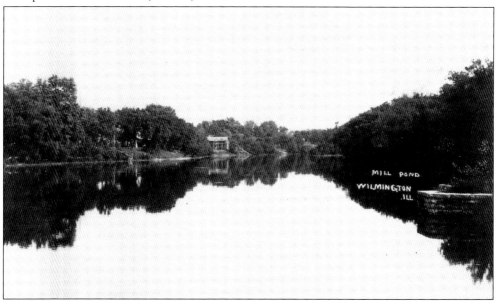

Improvements made to the Kankakee River in the 1870s not only made 21 miles of the river system navigable for boats but also created a series of dams and locks that created a fall of nearly 50 feet. This fall allowed for a large volume of water to be harnessed for power, even in the driest season. In the early 1870s, many business concerns, including flour mills and factories, began to utilize the river for power. This photograph from Engel's Bridge shows a view looking north at the millpond. (Author.)

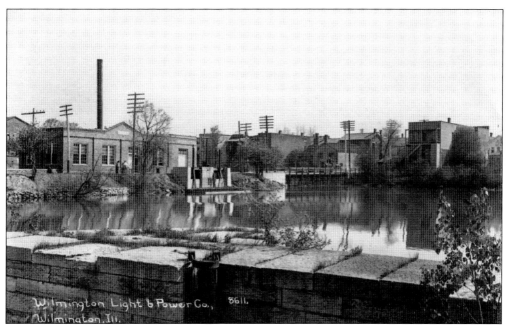

Looking east across the millrace from Alden's Island in Wilmington, the brick building to the left is the Wilmington Light and Power Company. Located on the west side of the millrace, the hydroelectric turbines of the power company harnessed river power to provide the town of Wilmington with electricity in the early 20th century. In the distance, directly behind the Eagle Hotel, Dam No. 2 is still visible in this photograph. (Author.)

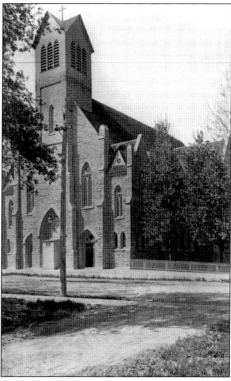

In 1851, the parishioners of St. Rose began construction of a small church building that was completed in 1855. In 1865, they built a larger church, but this soon became too small for the congregation. In 1883, construction of a new church began with a seating capacity of 700. The large stone church cost approximately $45,000 to build, and the first Mass was sung on Christmas Day 1886. For over 150 years, the St. Rose Parish has served the Catholic community of Wilmington. (Author.)

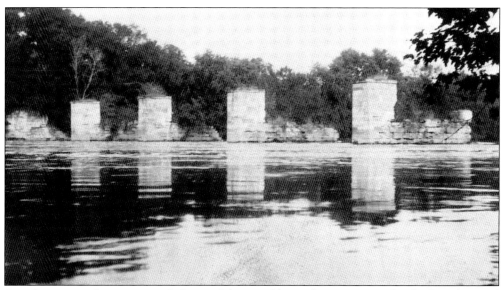

Canal engineers first envisioned the need for an additional water source for the Dresden Pool section of the canal as early as 1845. Once constructed, this water source was known as the Kankakee Feeder Canal. Originally constructed as a four-and-a-half-mile-long canal that ran northwest from the Kankakee River in Wilmington along its north side to the Des Plaines River in Channahon, the feeder was completed before the I&M Canal opened in 1848. Over time, the feeder also became a navigable transportation route between Wilmington and Channahon. Today, the remnants of the Kankakee Feeder Canal include several stone abutments of the aqueduct and the canal prism. The c. 1929 photograph above shows the piers of the old aqueduct over the Des Plaines River in Channahon. The c. 1940 photograph below shows the lock on the Kankakee River in Wilmington that was used to provide water to the feeder.

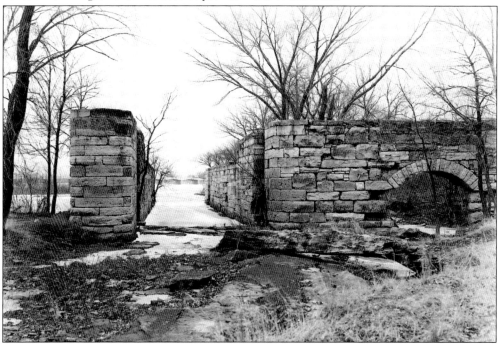

Three

GRUNDY COUNTY

The early pioneers of Grundy County came from southern Ohio, Pennsylvania, other eastern states, and a number of southern states. Most had been pioneers in older settlements in the states from which they had come or had been members of frontier colonies founded by their fathers.

Traveling on foot, these early settlers used schooner-shaped wagons to haul provisions and possessions over parts of the National Road, the Wilderness Road, or many of the old Indian traces that stretched across the Illinois prairie. Others traversed a combination of water routes available throughout the Old Northwest Territory, including the Ohio River, the Des Plaines River, and the Great Lakes.

Grundy pioneers mostly settled in the timber ridge that skirted the margin of the rivers, creeks, and ravines in the area. This timber ridge provided a comfortable buffer zone between the banks of rivers and the sea of prairie grass and flowers, which had yet to be conquered and controlled.

Negotiating the prairie, pioneers selected their sites, built their cabins, and established their early settlements that were scattered all through the area. Soon after, economic forces and social progress changed the landscape of Grundy County. As a result, communities developed, markets formed, roads improved, and entrepreneurial spirit thrived. In time, religious congregations organized, churches emerged, and schools started.

Canal commissioners and private speculators platted numerous towns in the 1830s and 1840s, including Channahon and Morris, as well as other towns that did not survive the depression of 1837 and the economic woes that soon followed.

Joseph Shoemaker is believed to be the first white settler in Channahon Township. Shoemaker arrived from Ohio and soon made a land claim. Settlement patterns soon developed, and early pioneers led by George Tyron, Myrvin Benjamin, Salmon Rutherford, Issac Jessup, William Peck, Joseph Fryer, Peter McCowan, E.G. Eames, and others began to inhabit the area. In 1845, the village of Channahon was laid out by Myrvin Benjamin and was first called DuPage, after the river that flowed through the area.

The town of Morris was platted in 1842 and incorporated eight years later. The town is named for Isaac N. Morris, a commissioner for the Illinois and Michigan Canal. The city became an important regional shipping center with the completion of the canal. During the early years, the canal prospered, carrying freight and passengers to distant towns and markets, but passenger traffic soon waned as the Chicago & Rock Island Railroad passed through the area in 1852, providing competition for the canal and shifting the business district north near the tracks.

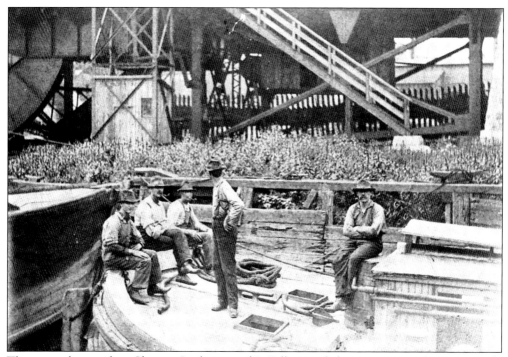

The various boatyards in Chicago, Lockport, and LaSalle provided an opportunity for many people to make a living on the canal. Some workers became craftsmen and honed their construction techniques in these boatyards. Others migrated to a life on a canal boat and became deckhands or eventually boat captains. The Foster family represents a typical canal-boat family. Joseph and George Foster arrived in Illinois in the 1850s and settled in Morris. Joseph began as a mule driver and then became an owner of several boats. George was shipper and then a locktender at Lock No. 8 at Aux Sable. The c. 1897 photograph above shows Joseph William Foster (the son of Joseph), who was born on a canal boat and became the captain of the *City of Pekin*, at right smoking a pipe by the cabin. The c. 1936 photograph below shows the *City of Pekin* in disrepair. Constructed in Chicago in 1875, the grain boat was converted to steam in 1894.

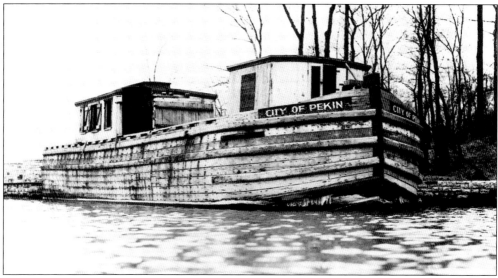

The span between 1000 A.D. and the coming of the European explorers and settlers is known as the Mississippian Period. The Briscoe Mound's archaeological site is located on Front Street along the Des Plaines River near the I&M Canal. The two well-preserved Indian mounds are situated along the western side of the Des Plaines River and date to approximately 1000–1200 A.D. (Author.)

The DuPage River is a tributary of the Des Plaines River and actually begins as two separate streams. The West Branch meets the East Branch at a spot between Naperville and Bolingbrook. The combined DuPage River continues south from there through Plainfield, West Joliet, Minooka, and Channahon before finally meeting the Des Plaines River. This postcard shows a photograph of the DuPage River in Channahon. (Author.)

The Minooka Widewater was one of several slightly wider sections that were constructed along the I&M Canal to act as turning basins or places used for loading and unloading barges. In 1860, a grain elevator was constructed by A.P. Carpenter along the east side and was known as Carpenter's Landing. Largely intact today, this wide-water area was originally around two miles long and from 400 to 600 feet wide, and was located just north of Lock No. 6 in Channahon. (Author.)

Early canal boats were towed by mules along a towpath adjacent to the waterway. Usually, two mules pulled a 150-foot-long line that was attached to the middle of the canal boat. The canal boats were about 100 feet long and about 18 feet wide and were designed to haul the maximum amount of tonnage or passengers. A 10-foot-wide towpath was cut for the mule driver, who helped tend to the mules as they walked along the canal. This photograph shows the remnants of the old towpath through Channahon.

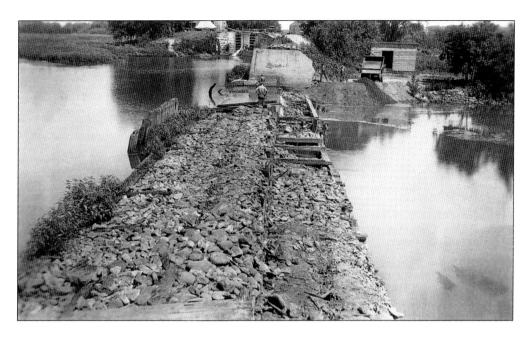

The origins of the Channahon Dam can be traced to the construction of the I&M Canal. Constructed between 1836 and 1848, the canal played a crucial role in the development and growth of Chicago. The course of the canal required that numerous streams, creeks, and rivers be crossed. In Channahon, canal engineers decided that connecting the canal directly to the river would be more economical than constructing an aqueduct over the river. Locks were constructed on either side of the river, and canal builders dammed the DuPage River to create a slack-water impoundment. The original dam was a timber-crib structure that was built in the late 1840s. These c. 1935 photographs show the construction of a new concrete dam over the DuPage River to help improve the recreational amenities of the area.

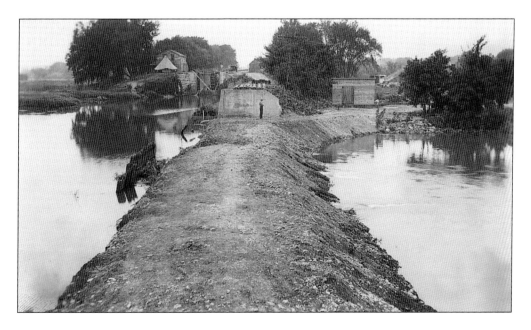

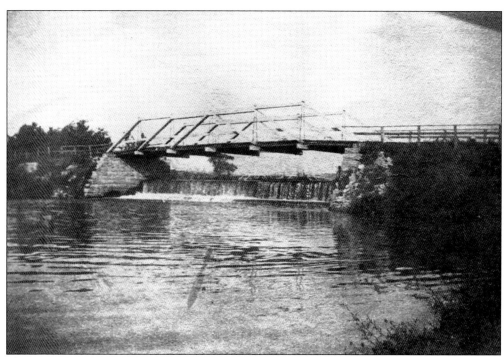

The original timber-crib dam over the DuPage River was eventually replaced with a more reliable dam that was constructed from quarried stone in 1877. Although this stone dam was more reliable, it did experience numerous repairs throughout the years, including in 1918, 1920, and 1925. The dam was constructed to block the DuPage River and cause the water to be diverted into the canal as a natural feeder. The c. 1906 photograph above shows a view of the bridge over the stone dam looking south across the river. The dam was reconstructed in 1934 by the CCC for recreational purposes. The c. 1910 photograph below shows a view of the bridge from the towpath.

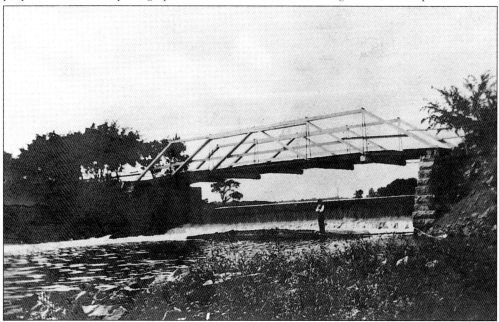

There was a continuing problem keeping the minimum six-foot depth of water in the canal, which was 60 feet wide at its narrowest. At Bridgeport, the eastern terminus, a steam-driven station pumped water from the Chicago River. In addition, four feeder canals along the route supplied water. In Channahon, the Kankakee Feeder Canal was carried across the Des Plaines River by a stone aqueduct. This 1942 photograph looks southeast along the old Kankakee Feeder Canal.

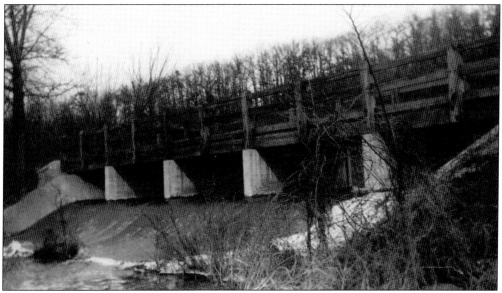

This 1942 photograph by C. Gaudio shows a downstream view of a wooden bridge and concrete spillway between the Des Plaines River and the I&M Canal. This image is near the Kankakee Feeder Canal. To keep the six-foot minimum depth in the canal, water was supplied by four feeder canals. The Kankakee Feeder Canal carried water over the Des Plaines River by a stone aqueduct and was located near McKinley Woods in Channahon.

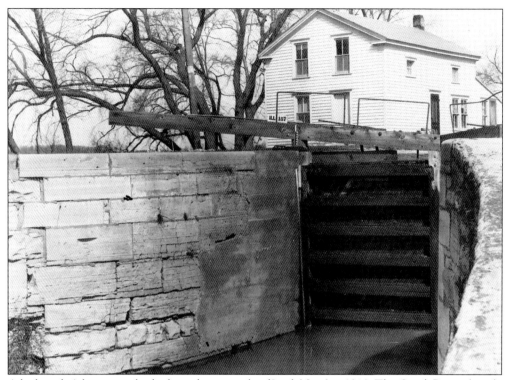

A locktender's house was built along the west side of Lock No. 6 in 1848. The Greek Revival–style structure was constructed in Lockport and floated down the canal to its present location. A smaller locktender's structure was built to the west of Lock No. 7; this was razed in 1910. The original c. 1846 timber-crib dam was replaced by a stone dam in 1877, and in 1934, a new concrete dam was constructed. The dam functioned as a bridge and barrier boom, keeping canal boats from being carried into the DuPage River and allowing mules to tow barges between the upper and lower docks. The photograph above shows a view of the locktender's house at Lock No. 6 looking north. The photograph below provides a view of Lock No. 7 looking east across the dam toward Lock No. 6. A small shack used by the locktenders can be seen on the left.

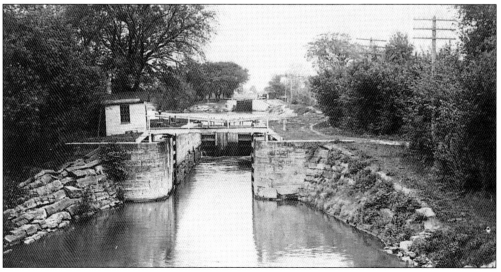

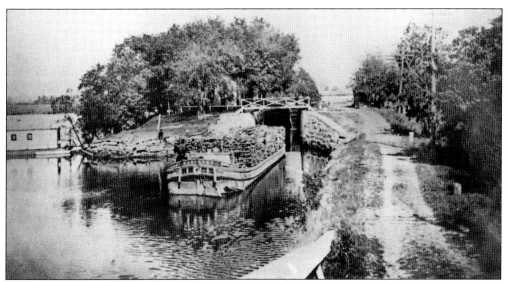

The construction of the I&M Canal forever changed the nature of trade in the Illinois River Valley. When the canal opened in 1848, trade that was once channeled through St. Louis was now directed to Chicago. Over time, the canal stimulated agricultural development in the region and prompted the growth of businesses in Chicago that were directly dependent on agriculture. In the first decade after the canal opened, the variety of products transported along the canal included wheat, corn, oats, flour, sugar, salt, pork, coal, stone, and lumber. The photograph above shows the *Margaret,* a steam-powered canal boat, entering Lock No. 6 and carrying large stacks of lumber from McKinley Woods. The photograph below shows the locktender at Lock No. 6 operating the valves that control the water flow into the lock chamber. The locktender's house is in the background.

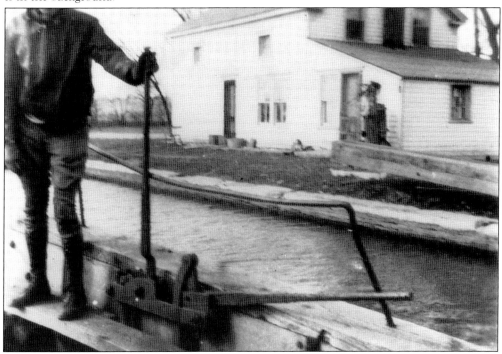

The I&M Canal crosses the DuPage River on the upstream side of the Channahon Dam. The canal is separated from either side of the river by a set of locks. Lock No. 6 on the north side of the river maintains the canal's water surface nearly seven feet above the DuPage River. The c. 1936 photograph above shows a view of Lock No. 6 with the north gates open and looking up the canal toward the Minooka Widewater. The DuPage River is visible through the trees. The c. 1920 photograph below shows the south gates of Lock No. 6 from the river. The gates are closed in this picture, and the balance beams, winch, and bridge used by the locktender to cross back and forth can be seen.

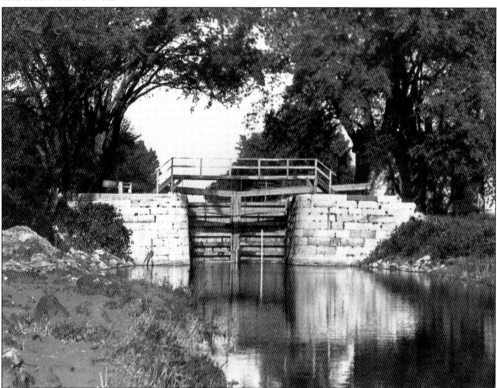

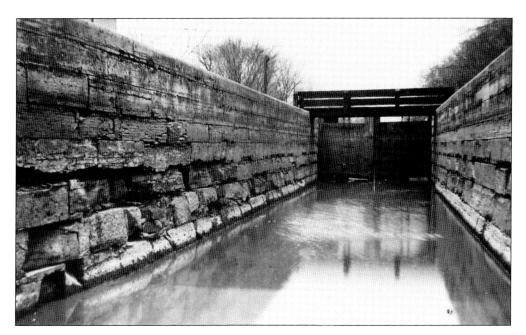

Most of the locks and wooden gates constructed along the I&M Canal followed a common set of specifications and were based on a 10-foot lift. Variations in the design of the locks did exist along the route, such as Locks No. 1 and No. 2 in Lockport. To ensure a 10-foot-lift lock, the I&M Canal locks required an 18-foot wall height and a foundation that was over 11 feet thick. The typical lock chamber measured 110 feet long by 18 feet wide and would accommodate canal boats that were constructed to meet these dimensions. The c. 1970 photograph above shows the chamber of Lock No. 6 with the northern gates closed. The c. 1997 photograph below shows a similar view of Lock No. 6 with no water in the chamber. (Below, author.)

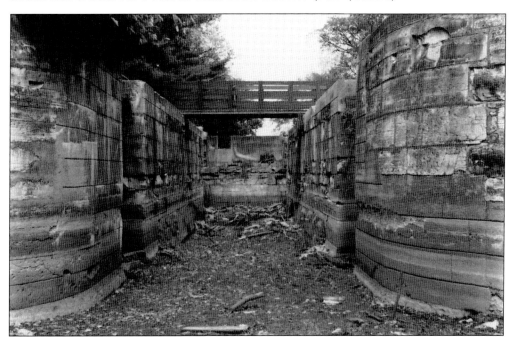

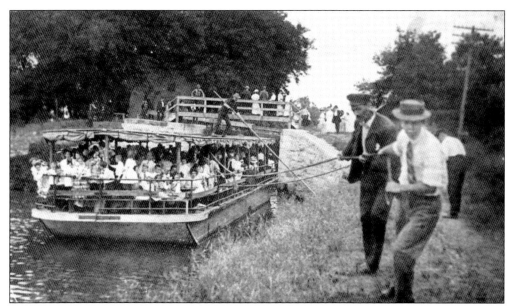

In the 19th and early 20th century, boats that carried passengers and small freight were called packet boats—those called packets just carried passengers. The word *packet* means a small pack, package, or parcel of importance. By the mid-1850s, the Chicago & Rock Island Railroad effectively ended the passenger trade of the packet boats, although they continued for years to take passengers on excursions along the I&M Canal. This photograph shows passengers being hauled through Lock No. 6.

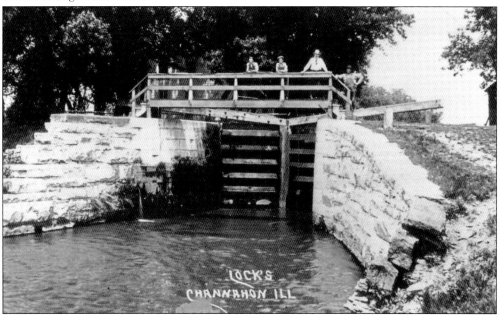

The growth of Grundy County can be directly traced to the building of the Illinois and Michigan Canal. With the help of many foreign-born workers, the canal was dug through the northern part of the county and connected the cities of Channahon and Morris to the east and west sections of the canal. In this photograph, people can be seen standing on the footbridge of Lock No. 6 near the locktender's house, which is still standing today, one of two left along the canal.

The dam constructed between Locks No. 6 and No. 7 was to impound the DuPage River and divert water into the canal as a natural feeder. Connecting the canal directly to the river proved more economical than constructing an aqueduct over the river, and it provided a perfect natural solution to bring needed water into the canal. This c. 1937 picture shows the closed gates of Lock No. 7 holding back the waters of the DuPage River.

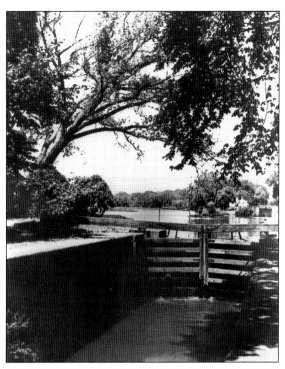

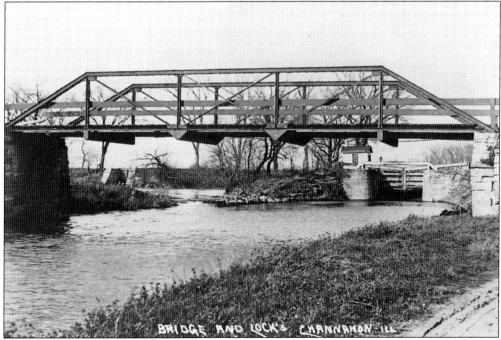

This c. 1920 photograph provides a glimpse of Lock No. 7 in Channahon looking north. The small shack used by the locktenders is visible near the lock gate. To the left, a small sluice gate adjacent to the lock that conveys a small amount of water flow from the DuPage River into the canal can be seen. Traditionally constructed as a wooden or metal plate, sluice gates were commonly used along the I&M Canal to control water levels and flow rates.

In the early 1830s, Salmon Rutherford constructed an inn in a town called Dresden, which he platted along the future route of the I&M Canal. Known as the Dresden Inn, the hostel was built to accommodate and cater to the stagecoach traffic that came through the area. The town of Dresden flourished for a time and became important enough to warrant a post office that operated for a short time in the 1830s. This photograph shows the old Dresden Inn located along the old stagecoach route. (Author.)

The construction of the I&M Canal through Grundy County brought many Catholics to the area. With this growth in population, St. Anthony's became the first Catholic Church in Grundy County, and Masses were celebrated by father Hippolyte DuPontavice beginning in 1841. Land was purchased for $1 four years later, and a church was erected at the foot of Dresden Hill. By 1864, a decision was made to build a church in the village of Minooka, east of St. Mary's Cemetery on Ridge Road. (Author.)

This structure at the old settlement of Dresden is thought to be the I&M Canal's last surviving mule barn. Mule barns housed mules when they became tired from towing boats along the canal. These barns were maintained about every 12–15 miles along the canal route. The old mule barn at Dresden was also used as a granary, where grain was stored in sacks for shipment on the canal. This c. 1975 photograph shows the old mule barn looking north across the canal.

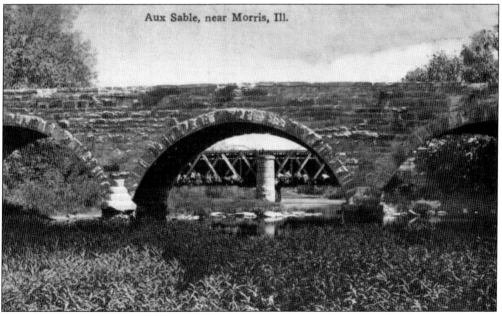

Aux Sable Creek was a natural barrier to the construction of the I&M Canal. Because the creek was a natural watershed, the I&M Canal engineers had to construct a 136-feet aqueduct over Aux Sable Creek. The Aux Sable Aqueduct is one of four aqueducts built along the canal as a solution to transporting canal boats over other bodies of water. In this picture, the aqueduct can be seen in the distance through the arch of the bridge.

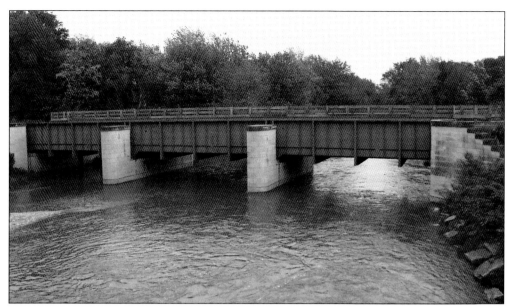

Constructed in 1847, the first aqueduct at Aux Sable Creek was built as part of the original I&M Canal construction project. This wooden aqueduct was replaced in 1927–1928 by a steel structure. In 1948, the abutments and piers were strengthened, and the towpath bridge was rebuilt in 1970. The Aux Sable Aqueduct spans 136 feet across Aux Sable Creek and is 18 feet wide. The steel aqueduct, shown here, was again stabilized as part of infrastructure improvements done along the canal in the late 1990s. (Author.)

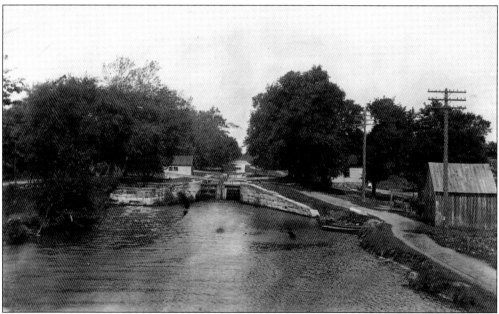

During the early years of navigation along the canal, packet boats carried passengers, and barges would transport a variety of commodities such as grain, coal, stone, and lumber. Packet boats would travel at the rate of five to six miles per hour, while barges, with heavier loads, would travel at the slightly slower rate of approximately three miles per hour. This c. 1920 photograph shows Lock No. 8 looking east. The Aux Sable Creek aqueduct is located just east of Lock No. 8.

Some of the first canal boats used on the I&M Canal were brought from the east via the Great Lakes. By the late 1850s, the majority of vessels were constructed locally at boat yards along the route at Bridgeport, Lockport, and Peru. While construction techniques varied, most boats were approximately 15 feet wide and 100 feet long, and these dimensions were dependent on the size of the locks along the route. The canal boat in this 1912 photograph is carrying a cargo of salt as it is passing through Lock No. 8.

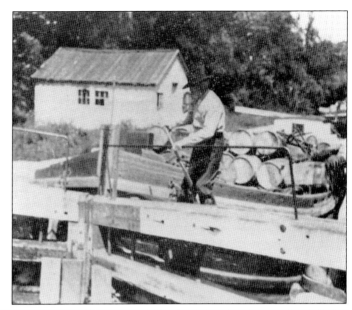

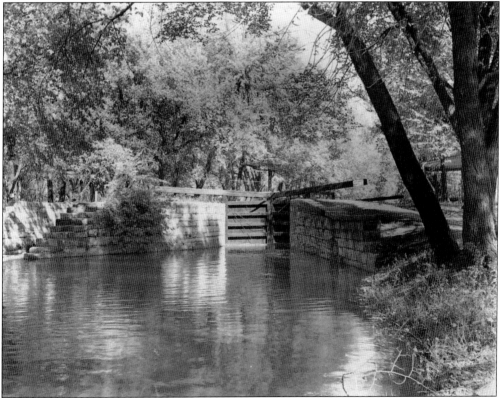

Stretching 96 miles through four counties, the I&M Canal was a six-foot-deep channel that was a minimum of 60 feet wide at the top, 36 feet wide at the bottom, and required 15 locks (originally 17) to adjust to elevation differences along with numerous aqueducts and multiple feeder canals to operate properly. This c. 1930 photograph looks east into Lock No. 8 at Aux Sable; the wooden lock gates and water bypass on the left are still visible.

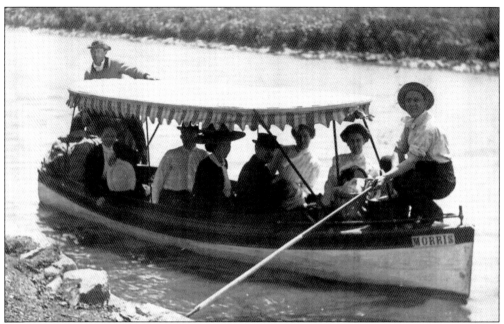

Passenger traffic on the I&M Canal during the early years of operation was completed by packet boats. At a speed of six miles per hour, a packet boat could travel the 96-mile canal from Chicago to LaSalle in approximately 22 hours. The typical packet boat had a cabin or enclosed area, which sometimes included a canvas or screen cover, to allow passengers to eat meals, sleep, and enjoy the trip. By the late 1850s, however, travel by packet boat began to wane as passenger travel migrated to the newly constructed Chicago & Rock Island Railroad, which paralleled the I&M Canal route from Chicago to LaSalle. These early-20th-century photographs show how passengers still enjoyed trips on the waterway in a variety of old canal and excursion boats.

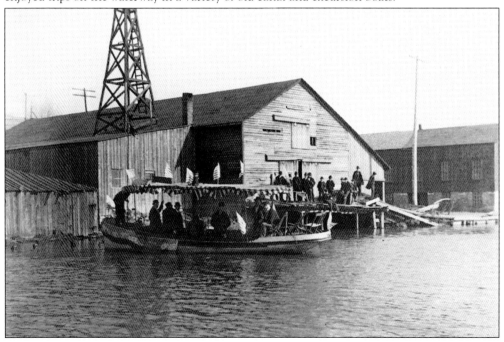

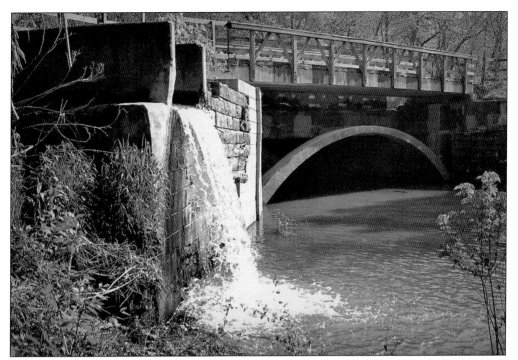

Morris is one of several towns in Grundy County that border on the I&M Canal. In 1845, Col. William L. Perce arrived in Morris, opened a dry goods store in a room of the American House Hotel, and took the contract to build the aqueduct across Nettle Creek on the west side of town. Stone for constructing the aqueduct was quarried seven miles west of Morris near the riverbank. The original red sandstone was inferior to other stone used along the canal and disintegrated over time. The aqueduct (shown above) had to be rebuilt, and the wooden aqueduct was removed and replaced with a steel structure in 1910. As shown in the image below taken by local photographer George Bedford, cofferdams were built to hold the water in the canal while the old structure was removed and repaired. (Above, courtesy Joe Balynas.)

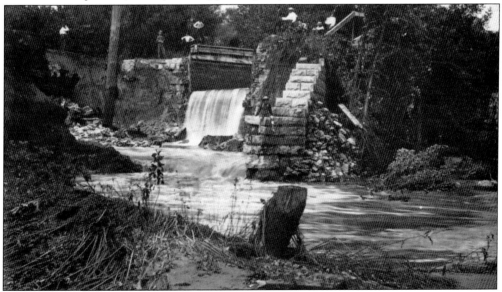

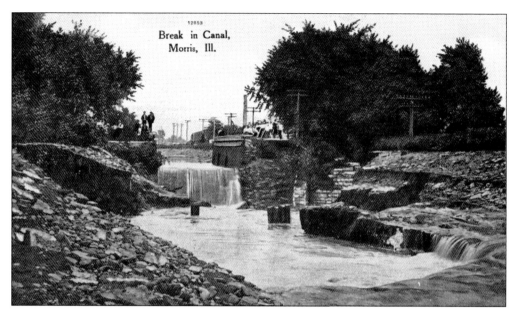

In the early-morning hours of July 31, 1907, one of the worst breaks experienced in canal operation occurred at the aqueduct just west of the Coleman Works. A full 40 feet of the canal towpath immediately adjoining the aqueduct structure was carried out along with the protecting wing walls forming the approach to it. At the time, the damage was estimated to be $5,000–$6,000. An article about the break appeared in the *Morris Herald* and questioned the future of the canal in the area.

A bit of ingenious engineering is required to construct aqueducts to cross the streams, creeks, and rivers on the canal route. Along the 96-mile trek through the wilderness, the I&M Canal needed a series of 15 locks to navigate the 141-foot elevation change from Chicago to the Illinois River. The canal route also needed four aqueducts to carry the canal across other bodies of water. Local photographer George Bedford took this unique photograph of the Nettle Creek Aqueduct in Morris.

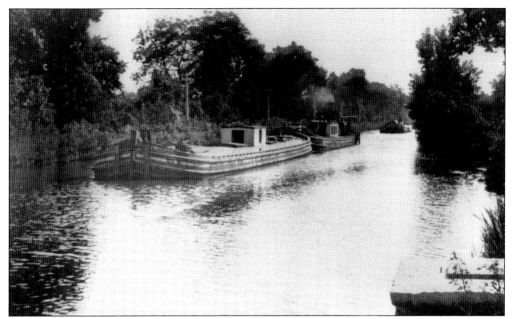

Hundreds of canal boats plying the waters of the I&M Canal between Chicago and LaSalle were once a common site during the 19th century. Construction of canal boats varied by location, most likely related to the customs, training, and peculiarities between craftsmen and construction practices used at the various boatyards along the canal. This c. 1910 photograph shows canal boats near the town of Morris.

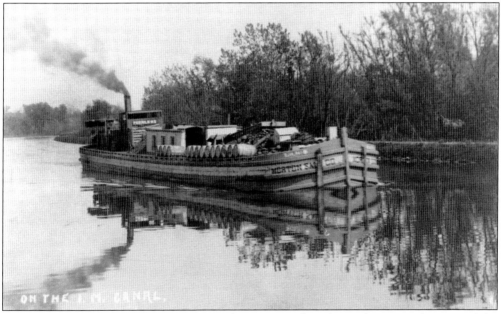

Morris and Channahon were two towns that prospered in the 19th century because of the transportation network tying Grundy County with Chicago and the East Coast markets. Beginning in Chicago and ending in LaSalle, the canal was the first link between the Great Lakes and the Mississippi River. The western section of the canal continued to operate until 1933, but the last boat to travel past the town of Morris was in 1914.

Gebhard Woods in Morris is bordered on the south by the I&M Canal and to the north by Nettle Creek. The Grundy County Rod and Gun Club purchased Gebhard Woods from Adelaide Gebhard in 1934, developed it, and then donated the land to the state of Illinois to be further developed and maintained as a state park. Members of the CCC were employed to landscape the grounds. The site of the old Gebhard Brewery was located just east of the state park.

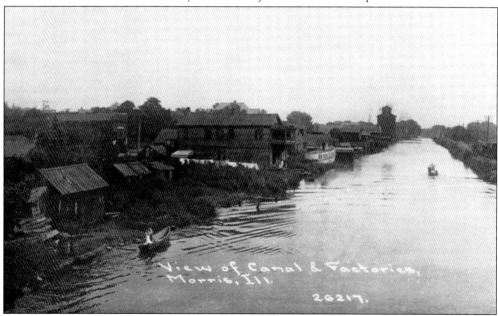

The I&M Canal was one of Morris's greatest assets in its early years and the first public highway through the county. Once opened, the canal brought entrepreneurs to Grundy County, and numerous manufacturing businesses, such as lumber mills and grain suppliers, arrived in Morris. In this view of the canal looking east from Morris, many early businesses that used the canal can been seen in the distance, including Gebhard Brewery, Coleman Hardware, and the Woelfel Tannery.

This photograph shows the main building and brew house of the Gebhard Brewery. Founded by German immigrant Louis Gebhard in 1866, the brewery's product was known throughout the state because the finest quality malt, grit, and foreign and domestic hops were used in the process. The surviving buildings include the brick bottling plant and the larger brew house. The brewery was located south of town on Washington Street just north of the Illinois River and the I&M Canal. (Author.)

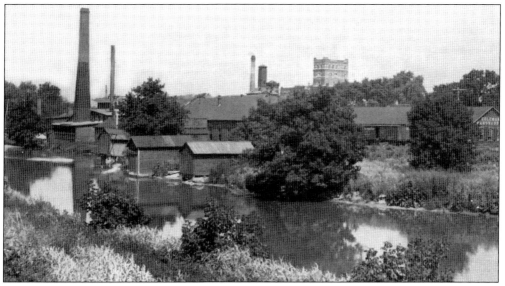

This image shows the Coleman Hardware Company in Morris. The business began as the Hall Furniture Company shortly after the Civil War in 1867. After a series of name changes, the company reorganized under the name of the Coleman Hardware Company. The business employed 300 workers to produce pulleys, locks, hinges, manholes, iron toys, and other specialties. The business utilized the I&M Canal and the Rock Island Railroad to unload raw materials and send products to market.

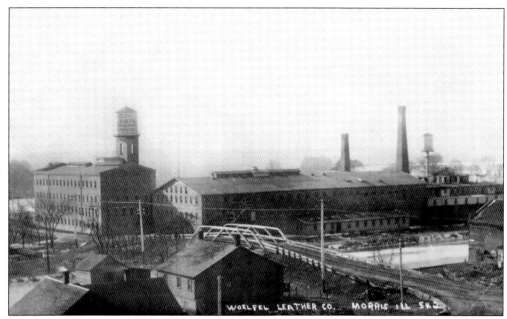

This photograph shows the Woelfel Tannery in Morris. The building, which was first owned by the Knoblock brothers, was established in 1858 and sold to George Woelfel in 1863. The surrounding farm country supplied the necessary hides for all leather products, such as harnesses, boots, shoes, and so on. An extensive brick addition was made to the plant in 1881, doubling its capacity and workforce to nearly 30 men. Many of the products made in this plant were shipped on the I&M Canal. (Author.)

In the summer of 1996, a series of thunderstorms deposited over 15 inches of local rainfall, which caused massive flooding to the Channahon area and the destruction of a dam across the DuPage River. The unexpected result was that parts of the canal were left dry, exposing seven canal-boat hulls near Morris. The Illinois Department of Natural Resources contracted with Fever River Research of Springfield to conduct an archaeological study of these historic resources in 1998. This image shows Lock No. 6 with no water in the chamber as the repair work on the dam was being completed. (Author.)

Four

LaSalle County

Long before settlers came to the region, the Illinois River Valley was inhabited by numerous Native American tribes, including the Illinois, Iroquois, Sac, Fox, Kickapoo, and Potawatomi. Louis Jolliet and Father Marquette were the first recorded European explorers to journey through the area in 1673. Exploring the region in the 1680s, Robert Cavalier Sieur de La Salle, a more ambitious French explorer and the namesake for the county, traveled through the area. His desire for empire and settlement centered on building forts and issuing land grants. Plagued by Native American resistance and his own ambition, La Salle's plans were never favored in Quebec, even after his death in 1687.

In the decades after Illinois declared statehood, settlers began moving into the Illinois Valley from such places as Virginia, Connecticut, Kentucky, the Carolinas, Massachusetts, and New York. Among the first known settlers in LaSalle was Aaron Gunn, who arrived from Massachusetts and purchased land in the area in the early 1830s. Others soon settled nearby, including Samuel Lapsley, who arrived from St. Louis, and Burton Ayers, who came from Ohio. LaSalle County was officially established on January 15, 1831.

Before construction on the I&M Canal began, canal commissioners encouraged early settlers to move to the region and form communities. In the 1830s, northeastern Illinois had few inhabitants and mostly catered to those involved in the trade ventures. The end of the Black Hawk War brought a flood of adventurers and speculators to the western frontier, and land fever soon spread throughout the region. Small towns, especially those situated on the banks of rivers, were laid out, and fledgling enterprises along those marine routes were started.

The towns of Chicago and Ottawa were platted by the canal commissioners in 1830 to serve as the gateway to the I&M Canal via the Chicago River and the western terminus on the Illinois River. By 1836, canal commissioners made the decision to locate the western terminus farther west, and the town of LaSalle was platted in 1838.

With fertile farmland and access to large-scale grain terminals in Chicago, towns and communities prospered along the I&M Canal, especially in LaSalle County, where grain facilities were numerous. Once the I&M Canal opened in 1848, the population of LaSalle County increased, and the town of LaSalle, with its steamboat basin, became a place of tremendous activity. In time, LaSalle became the location where northern and southern cultures came together.

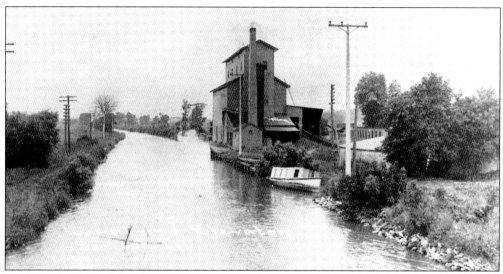

In the early 1860s, John Armour, a prominent businessman in Ottawa, constructed a grain warehouse along the north bank of the Illinois and Michigan Canal overlooking downtown Seneca. Rising four stories above its limestone foundation, the 65-foot-tall grain warehouse, or grain elevator, represents the oldest frame elevator still standing along the canal. Ownership of the Armour Elevator changed several times during the mid-19th century, and by the 1890s, it was known by most locals as Hogan's North Elevator, named after Martin J. Hogan, who purchased the complex in 1886. Today, the structure is known as the Seneca Grain Elevator, and the building (Armour's Warehouse) was listed in the National Register of Historic Places in 1997. The c. 1895 photograph above shows the Hogan Elevator looking west from the I&M Canal. Taken from the same location (the old canal bed), the photograph below shows the Hogan Elevator as it appears today. (Below, courtesy Joe Balynas.)

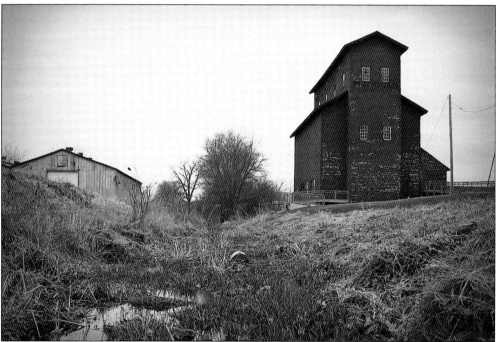

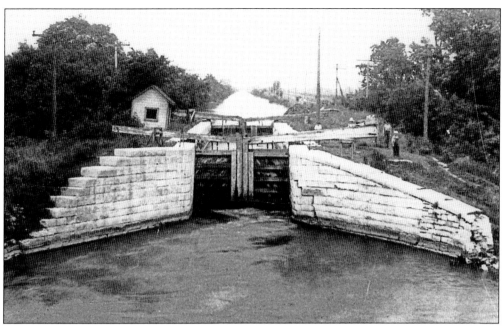

The construction of the I&M Canal from Bridgeport to LaSalle-Peru required a system of locks, dams, aqueducts, and bridges to negotiate the 97-mile route. To compensate for the 141-foot drop in elevation from Lake Michigan to the Illinois River at LaSalle, a series of locks was necessary at various locations. From 1848 to 1871, there were 17 locks on the canal, but two summit locks—one at Bridgeport and the other several miles north of Lockport—were removed after the Deep Cut project of 1871. Most of the remaining 15 locks were 18 feet wide and 110 feet long and generally had a lift of between 5 and 12 feet. The c. 1890 photograph above shows Lock No. 9 at Marseilles. The early 20th century photograph below shows Lock No. 13 in Utica. The Black Ball Mine is visible in the background, and the locktender's house is located on the right.

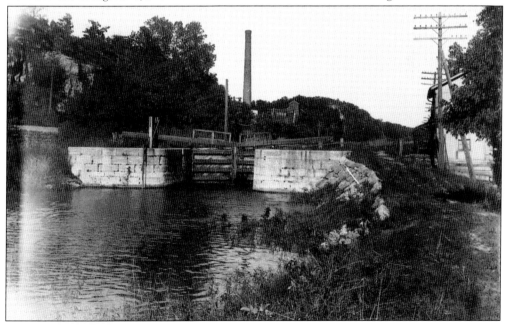

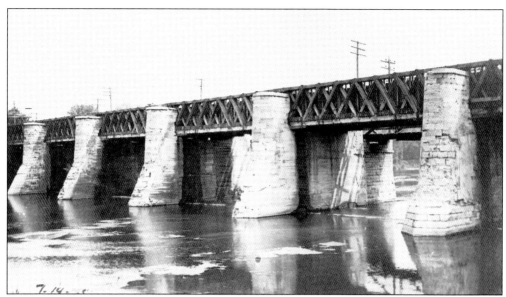

Canal engineers had to design and construct four aqueducts to carry the canal over rivers and creeks. The four principal aqueducts were over Aux Sable and Nettle Creeks and Fox and Little Vermilion Rivers. The largest of the aqueducts was built over the Fox River in Ottawa by local construction firm David Sanger & Sons. On June 5, 1838, the board of commissioners of the Illinois and Michigan Canal awarded Sanger the contract to construct the structure. Measuring 464 feet in length, the aqueduct bridged the river with eight spans supported by seven limestone piers and two abutments, and work was completed by the time the canal opened in 1848. Over the years, the stone piers and abutments were repaired, and the original wooden aqueduct was replaced with a steel trough in 1918–1919. The c. 1920 photograph above shows the aqueduct looking north (upstream) from the Fox River. Taken the around the same time, the image below shows a view looking west from the top of the aqueduct.

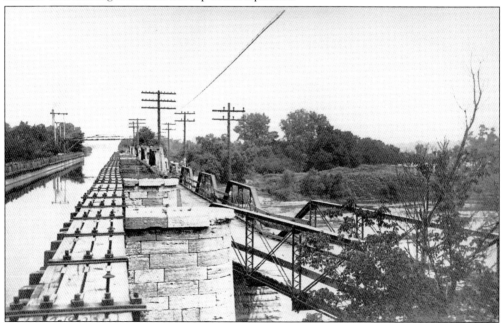

The original Fox River Aqueduct in Ottawa was constructed in a similar fashion to other aqueducts along the canal. The 1848 version was built of six timber Howe truss spans resting on seven limestone piers and two abutments. The wooden towpath bridge, which ran along the south side of the structure, fell into disrepair after 1870 when mule teams were no longer necessary. The Illinois Traction System extended the piers from the old timber towpath and created a railroad crossing over the river in 1903. In 1918, the federal government provided funds to improve western sections of the canal, and the four aqueducts were replaced with steel. The c. 1944 photograph above was taken from the east side of the aqueduct looking west. Old power line poles from the interurban are spaced along the south side of the aqueduct. The photograph below looking east across the river shows the stone piers extending south from the piers of the old interurban bridge. These limestone piers were added for an old roadway bridge that was built adjacent to the aqueduct and railroad bridge.

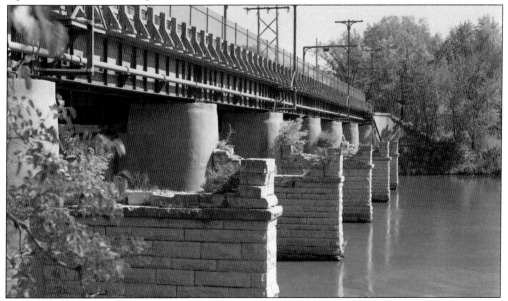

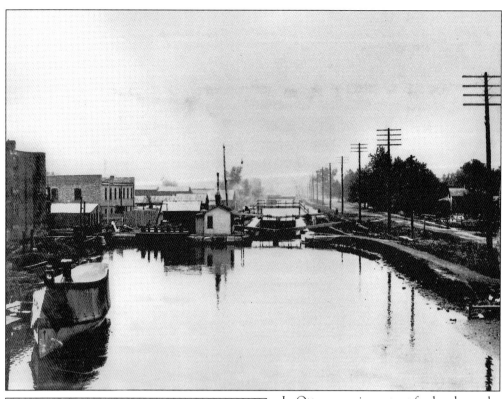

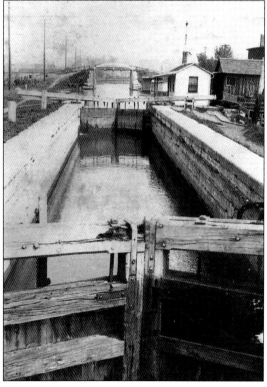

In Ottawa, an important feeder channel was located north of the main canal. The canal through the town was approximately 4.7 miles long and nearly 50 feet wide, and many mills and grain elevators were located along its route. At the location where the feeder joined the main canal, an additional channel known as the Lateral Canal ran south through town and emptied into the wide water of the Hydraulic Basin. The basin moved the water east for several blocks, then through a narrow mill race before spilling into the Fox River. This canal was used to regulate water levels in the I&M Canal in addition to providing hydraulic power to many businesses along its short route. The c. 1910 photograph above shows the Lateral Canal Lock at Superior Street looking north toward the I&M Canal. The towpath bridge can be seen in the background, and the locktender's shack is to the right, just beyond the north gate. Taken from the towpath bridge, the photograph at left shows a southern view towards the lock in 1912.

The Lateral Canal, sometimes referred to as the "sidecut," was supplied with water by the Fox River Feeder Canal located north of the Fox River Dam in Dayton. The Lateral Canal cut through the I&M Canal towpath north of Superior Street, dropped elevation through a limestone lock, and ran south along the east side of Canal Street where it entered the Hydraulic Basin just south of Main Street. The basin was oriented east-west along the south side of Mill Street and flowed east to LaSalle Street where it narrowed into a raceway that controlled the water as it flowed into the Fox River. The c. 1931 photograph at right shows the control gates into the Lateral Canal, which were located east of the Superior Street Lock and used to control the rate of water that supplied the Lateral Canal. The c. 1933 photograph below shows a view of the old Hydraulic Basin spillway, which provided the outlet for water to flow into the Fox River.

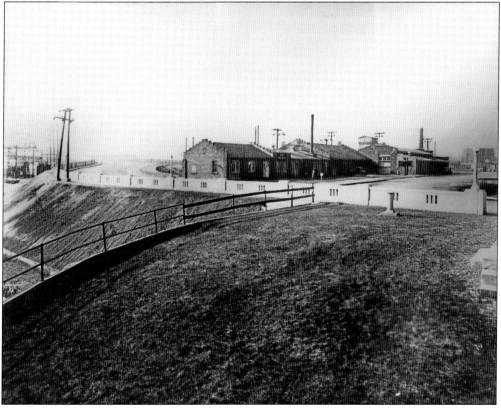

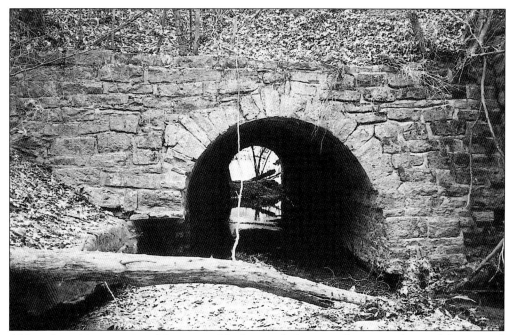

Although nothing remains of the original feeder canal, there is still some evidence of the original route in the topography of the area. The nearly five-mile-long feeder began just north of Dayton and ran south along the west bank of the Fox River, eventually following Lyman's Mound Road, North 2959th Road, paralleling the Burlington Railroad route, and then curving south to join the Main Channel of the canal. This c. 1993 photograph shows a culvert on the Fox River Feeder Canal.

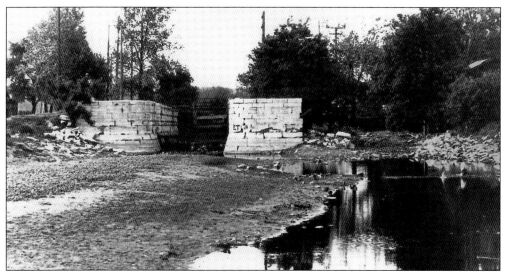

In 1931, teams of unemployed men from the area began to dismantle the Lateral Canal and its Superior Street Lock and fill in sections from the Main Canal near Superior Street south to Main Street. In short order, the Hydraulic Basin was also filled in between LaSalle and Clinton Streets and Mill Street; between LaSalle and Columbus Streets, it was widened and paved over. This 1931 photograph shows the Superior Street Lock on the Lateral Canal shortly before it was dismantled.

Although the I&M Canal continued to be used to ship bulk commodities along its route in the late 19th century, it was nonetheless experiencing a period of gradual decline and deterioration. As revenue diminished and various revitalization projects failed, competition from railroads and the construction of the Chicago Sanitary and Ship Canal ultimately doomed the I&M Canal. As canal boat traffic all but ceased by the 1920s, it was not until the period of the Great Depression that employment programs sparked a renewed interest in the canal and making improvements to the system. In the 1930s, CCC workers were employed in numerous programs geared to transforming the I&M Canal into a recreational parkway destination. In Ottawa, a plan to put local unemployed residents on the payroll was devised by Mayor Hubert J. Hilliard. Part of Hilliard's 1931 plan involved filling in the Lateral Canal and Hydraulic Basin, as well as the removal of dilapidated bridges spanning the canal and the Superior Street Lock. These c. 1931 photographs show the Lateral Canal in various stages of being filled in with dirt.

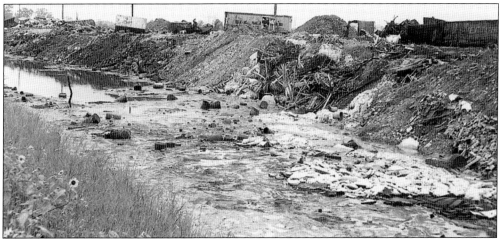

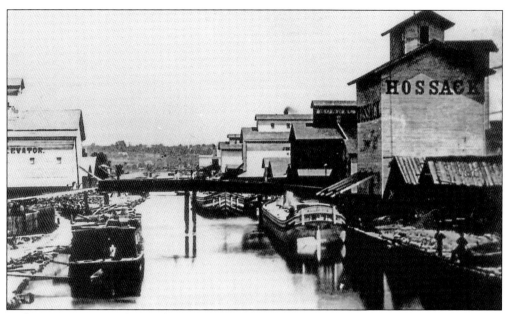

William E. Bowman, who resided and worked in Ottawa from 1857 to 1910, is considered one of the town's best-known photographers. In the c. 1870 stereograph above, Bowman captures the grain elevators that lined the Lateral Canal in Ottawa. The elevator on the right was owned by canal contractor and abolitionist John Hossack, who came to Ottawa from Chicago, where he worked on the I&M Canal. After arriving in Ottawa, Hossack worked in the lumber and grain trade. In 1854, Hossack constructed a Greek Revival home overlooking the south bank of the Illinois River and the city of Ottawa. Pictured below, the prominent home played a significant role in the Underground Railroad; as a strong opponent of slavery, Hossack hid fleeing slaves in his house. In 1860, Hossack and others were charged and convicted in federal court in Chicago for violating the Fugitive Slave Law. The home was added to the National Register of Historic Places in 1972. (Below, author.)

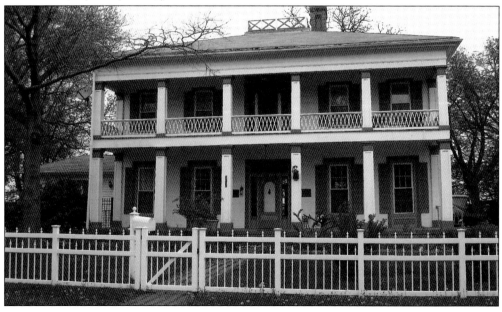

The Ottawa Tollhouse was one of several collectors' offices that operated along the canal route. These toll stations were important to the operations of the canal, as they collected revenue that was essential to the canal's operation and maintenance. While the original location is believed to be near LaSalle Street, it was moved to its present location on Columbus Street near the canal in the 1870s. This c. 1970 photograph shows the old structure.

In 1858, a series of seven political debates between Abraham Lincoln and Stephen A. Douglas were held around the state. The first of these debates was held in Washington Park Square in Ottawa, and both men were greeted by cheering crowds, numbering nearly 14,000. Although Lincoln lost the senatorial race to Douglas, these debates launched him into national prominence. On April 11, 1973, the location was designated as a historic district and added to the National Register of Historic Places. (Author.)

Built in 1858 by Illinois businessman, politician, and philanthropist William Reddick, this three-story, 22-room Italianate-style mansion has been a landmark in Ottawa for many years. Commissioned in 1855, construction began in the spring of 1856 and was completed a year later. The Reddick Mansion faces Washington Park Square and stands on the northwest corner of Lafayette and Columbus Streets in Ottawa. After Reddick's death in 1885, the house was willed to the City of Ottawa for use as a public library. (Courtesy Joe Balynas.)

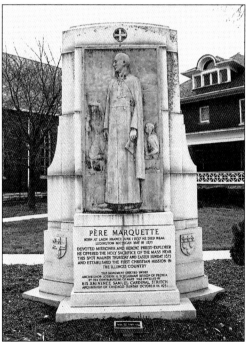

A monument to Father Marquette was erected on October 14, 1951, under Archbishop Joseph H. Schlarman, the bishop of Peoria. Located on the northeast corner of the St. Mary's Church property in Utica, Illinois, the stone sculpture captures a profile of the Jesuit missionary and has an inscription at the base. In April 1675, Father Marquette offered the first parochial Mass near this location in the presence of thousands of Native Americans. (Courtesy Joe Balynas.)

Grain elevators and warehouses lined the banks of the canal and river towns in Illinois in the 19th century. Often serving both the railroad and canal, these structures were an important link between prairie farmers and the broader domestic and international markets. The flow of grain was primarily from west to east along the I&M Canal and the railroads; other commodities were also shipped along the routes, including corn, oats, salt, sugar, and flour. Soon after the opening of the canal, facilities for storing and forwarding the products were established along the route. In the photograph above, the Utica Elevator can be seen along the bank of the canal. In the c. 1869 image below, a warehouse owned and operated by dry goods merchant James Barton can be seen on the edge of the canal.

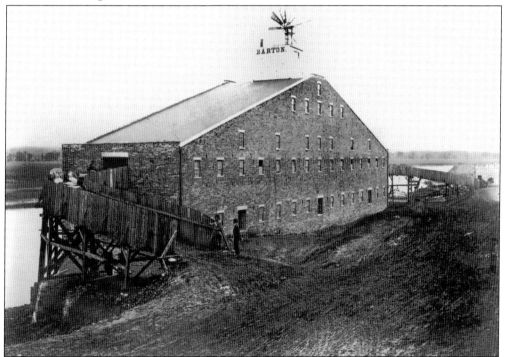

Located between Utica and LaSalle and near the mouth of Pecumsaugan Creek is an ancient St. Peter sandstone and Shakopee dolomite stone that was cut during the construction of the I&M Canal and the railroad a few years later. The image at left is a c. 1866 D.W.S. Rawson stereograph and is considered one of the earliest photographs taken of Split Rock. The c. 1902 image below shows a similar view from the tracks of the Rock Island Railroad, which was in direct competition with the canal for business. Notable is the addition of the Illinois Valley Railroad's electric interurban line running on the bridge across the canal and railroad tracks. The line was part of the Chicago, Ottawa & Peoria Railway, which ran along the Illinois River Valley between Joliet and Princeton and was one of the longest lines in the state.

The Hegeler-Carus Mansion was designed by architect William W. Boyington and constructed in 1874–1875 for Edward and Camilla Hegeler. The 57-room mansion is located on a bluff about six blocks north of the I&M Canal on a three-acre site that offered a beautiful landscaped environment. The mansion is situated just south of what was the Matthiessen & Hegeler Zinc Company, once the largest zinc-producing company in the nation and LaSalle's principal industry. Frederick W. Matthiessen and Edward Hegeler had come west from Pennsylvania in the mid-1850s in search of a suitable site for their zinc works and found LaSalle a perfect location, as it offered a shipping point on the I&M Canal, which connected Chicago with the Illinois River near the town. These photographs show the exterior of the seven-level, 16,000-square-foot residence, which is an example of Second Empire architectural design. The house was designated a National Historic Landmark on March 29, 2007. (Both, courtesy Hegeler Carus Foundation.)

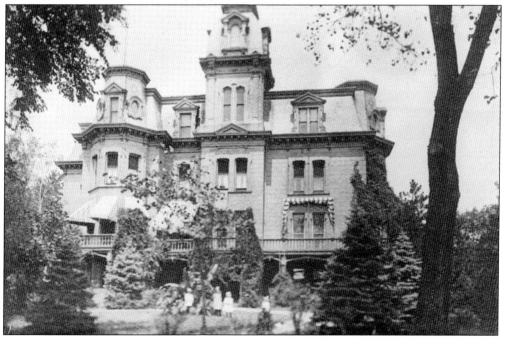

In 1885, clock inventor Charles Stahlberg established the United Clock Company in LaSalle-Peru, Illinois. The firm struggled for several years to make a profit, and poor financial management forced the company into bankruptcy by 1887. F.W. Matthiessen, the president of Matthiessen and Hegeler Zinc Company, purchased the company and changed the name to the Western Clock Company. By the early 1890s, the company was financially stable and produced nearly 400 units per day. In 1910, the company began selling and uniquely marketing its most famous product, the Big Ben alarm clock. In 1923, the management team adopted Westclox as the company name, and in 1930, the company merged with Seth Thomas Clock Company. Although the firm employed thousands of LaSalle-Peru residents by the early 1950s, a series of late-20th-century mergers caused the LaSalle plant to close by 1980. These photographs show the LaSalle plant, which was located on Route 6 in Peru. (Above, author.)

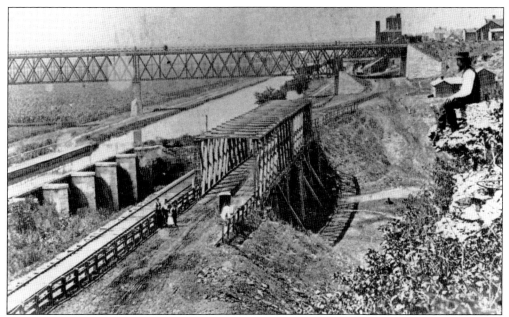

At the time of its construction, the Illinois Central Railroad Bridge spanning the Illinois River was one of the largest structures of its kind in the world. A portion of the north section of the bridge over the I&M Canal is shown in this 1866 D.W.S. Rawson stereograph image. The aqueduct that carried the I&M Canal over the Little Vermilion River can be seen in the center of the photograph. This rare photograph is considered one of the earliest of the canal.

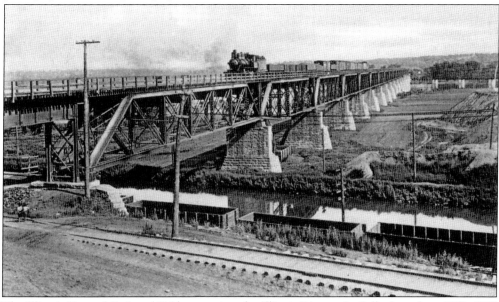

The Illinois Central Railroad Bridge crossing the Illinois River at LaSalle dates from 1853–1855 when the railroad line was constructed through the area. The original north-south bridge consisted of a series of cast and wrought iron Howe deck trusses that were supported by stone piers as it crossed the Illinois River and the I&M Canal. In 1893, the bridge was fully reconstructed, and additional changes were made in 1932. The bridge was abandoned in the late 1970s. This 1910 image shows the bridge looking south.

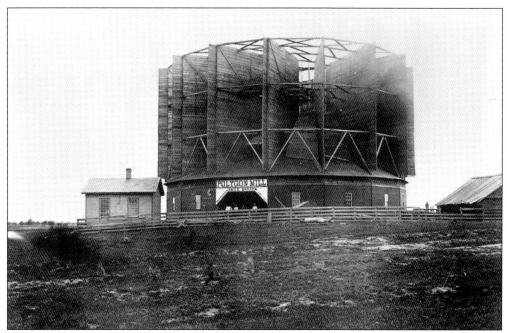

D.W.S. Rawson was a local photographer who resided in Peru, Illinois, for several years beginning in 1857. He is believed to be one of the earliest landscape photographers in the state and dabbled with the stereographic process, which gave the illusion of three dimensions when viewed through a stereopticon device. Rawson is also credited with teaching the basics of ambrotype photography to William Emory Bowman. The ambrotype process creates a positive image on a sheet of glass using the wet-plate, collodion process. This photographic process was in wide use by the mid-1850s and soon became more popular and less expensive than the daguerreotype process. Rawson and Bowman entered into a partnership together in Ottawa after 1860. These two c. 1870 Rawson photographs show locations in Peru. The photograph above shows the Polygon Mill, which was owned and operated by James Barton. The image below is a view of the river landing in town.

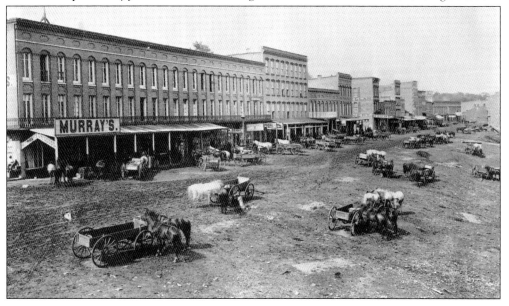

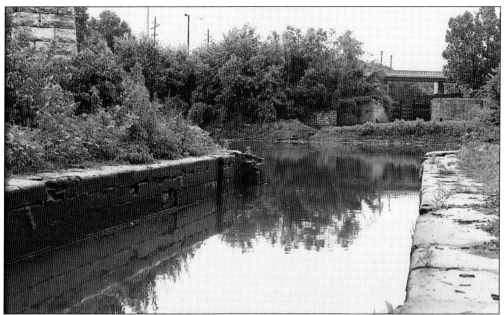

The western terminus of the I&M Canal is just west of the Illinois Central Railroad Bridge in LaSalle, Illinois. Before entering the deep waters of the Illinois River, canal boats needed to traverse Lock No. 14 (now restored) and Lock No. 15. Between the locks, a canal boat basin 640 feet long by 290 feet wide was constructed to accommodate barge traffic entering or leaving the canal. West of Lock No. 15, the canal commissioners created a steamboat basin for river traffic nearly 118 feet wide and a mile long. Today, Lock No. 14 is the only one of the 15 original locks that has been restored. The photograph above shows a view of Lock No. 14 looking east from Lock No. 15. In the photograph below, the canal basin, Lock No. 15, the steamboat basin, and the limestone piers of the old Chicago, Burlington & Quincy Railroad Bridge can be seen. (Both, courtesy Joe Balynas.)

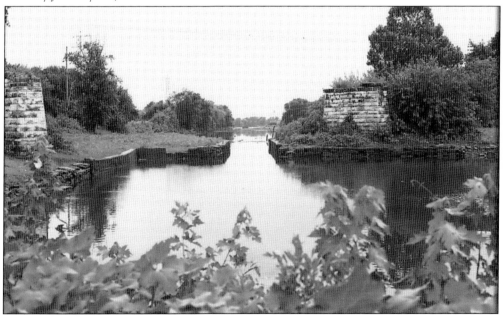

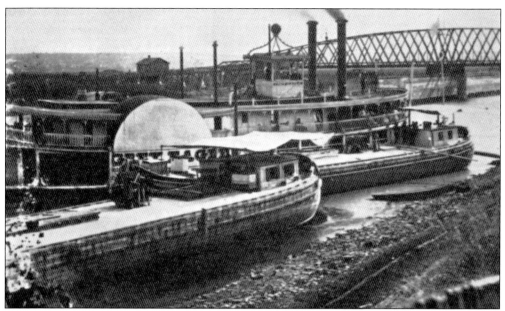

In 1836, the canal commissioners decided that the western terminus of the I&M Canal would be located at LaSalle, Illinois. By the fall of 1836, contracts were awarded for 12 sections on the western division, including a steamboat basin at LaSalle. Once the I&M Canal was completed in 1848, LaSalle-Peru became a place of tremendous activity. Local farmers now had a reliable way to ship their corn and wheat to Chicago and distant markets to the east. Steamboats arriving from New Orleans and other Mississippi towns unloaded sugar, coffee, molasses, and fresh fruits to be shipped on the canal to Chicago. Canal boats from Chicago brought lumber, stoves, wagons, and passengers to area. In time, LaSalle-Peru became the location where northern and southern culture came together. These images show various canal boats on the Illinois River along Peru's Water Street.

Five

SANITARY SHIP CANAL AND ILLINOIS WATERWAY

Chicago's growing population during the 19th century caused an increase in the amount of sewage being released into the Chicago River, contaminating the sluggish river, allowing the filth and foulness to drift into Lake Michigan, and polluting the city's water supply. After several outbreaks of cholera and dysentery epidemics, the Illinois state legislature took action and established a board of sewerage commissioners in 1855. That same year, Ellis S. Chesbrough arrived in Chicago with several ideas for sewer drainage, including raising the streets, building a sewer system, and ultimately deepening the I&M Canal to reverse the Chicago River and flush the city's sewage downstream.

The deepening of the I&M Canal, called the Deep Cut project, was completed in 1871 and enlarged the city's sewage handling capabilities, but the city's growing population strained the system, and during adverse weather conditions, such as heavy rains, the Deep Cut failed to maintain the reversal. The solution was to enlarge the water system using the same methods, but more effectively, to permanently reverse the Chicago River.

The recurring epidemics of typhoid, cholera, and other waterborne diseases that sickened residents caused the state legislature to create the Sanitary District of Chicago in 1889 to find a solution to the sewage disposal problems. The plan was to divert water from Lake Michigan and the Chicago River into a new drainage canal. In 1892, construction began on a large canal to improve transportation, dilute waste, and move it downstream. The Main Channel of the canal that opened in 1900 was extended nearly three miles downstream of Lockport to include the Upper Basin in Joliet by 1907.

In the first two decades of the 20th century, the Sanitary and Ship Canal and the Cal-Sag Channel made some deepwater shipping possible in the region, but the terminus was Joliet. Predictable deepwater downstream from Joliet on the Des Plaines and Illinois Rivers was unreliable, so the Illinois General Assembly passed legislation to authorize the construction and development of the Illinois Waterway, a project designed to provide a navigation channel between Lockport and Utica, in 1919. Construction of the modern Illinois Waterway project, which would deliver a final death blow to the I&M Canal, was started by the state of Illinois and completed by the US Army Corps of Engineers in 1933.

Cholera epidemics ravaged the city of Chicago during the latter part of the 19th century. The fast-paced growth of the city caused human waste and factory by-products and pollutants to seep into the Chicago River and flow out into Lake Michigan, endangering the city's water supply. Ellis S. Chesbrough's idea to deepen the I&M Canal to divert water downstream in 1871 proved ineffective, as it failed to maintain a constant reversal. The solution to the reversal idea would come later with the construction of the Chicago Sanitary Ship Canal. These construction photographs, taken in the late 1890s, show the Lockport Controlling Works with its series of seven vertical gates to control the flow of water in the new channel.

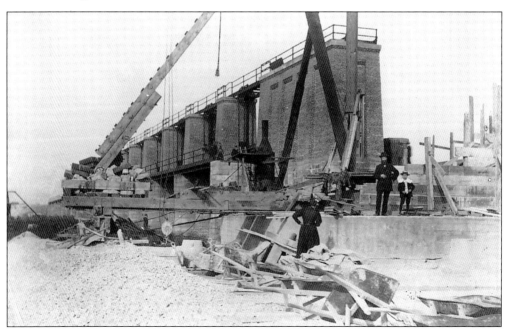

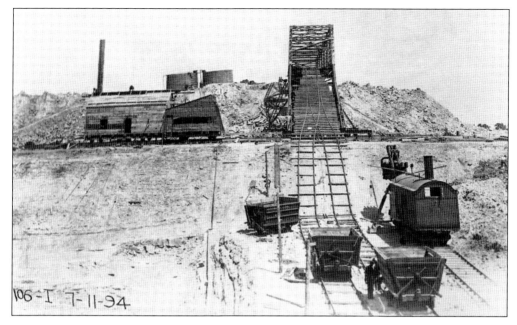

The plan to divert water from Lake Michigan and the Chicago River into a new drainage canal that ran southwest from Damen Avenue to the town of Lockport was a major undertaking that required massive rock, soil, and clay removal. These c. 1894 photographs show steam shovels and trolleys used to remove and haul dirt out of the canal. Unlike the building of the I&M Canal in the 1840s, when most of the digging was done by hand, steam shovels played an important role in digging a deeper channel through layers of soil, clay, and stone, while trolley cars added quick removal of the debris, which was a major task. It is estimated that the main channel construction removed nearly 30 million cubic yards of glacial deposits and over 12 million cubic yards of solid rock.

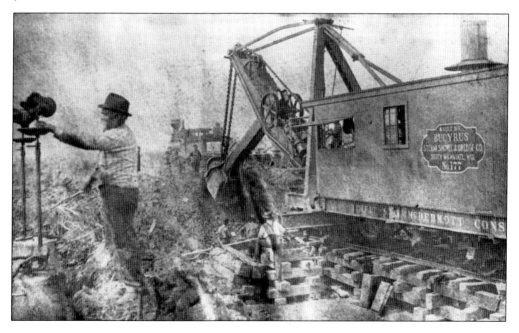

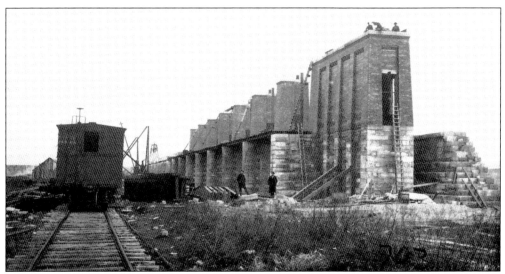

To divert the disease-laden sewage away from the drinking water supply in Lake Michigan, the City of Chicago began construction of the 28-mile-long canal in 1892. These photographs show the Lockport Controlling Works lift gates in Lockport during construction in the late 1890s. The seven waste gates were designed to control the level of water in the drainage canal and the Des Plaines River. The discharge of water from the Sanitary and Ship Canal is controlled by the lock and powerhouse at Lockport. The construction of the Chicago Sanitary Ship Canal was the first important work of the newly formed Sanitary District of Chicago (now the Metropolitan Water Reclamation District of Greater Chicago). The Main Channel of the canal that opened in 1900 was extended nearly three miles downstream of Lockport to include the Upper Basin in Joliet by 1907.

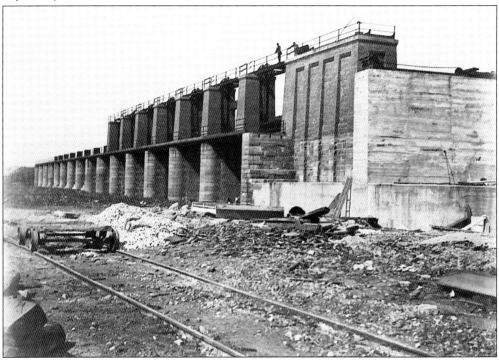

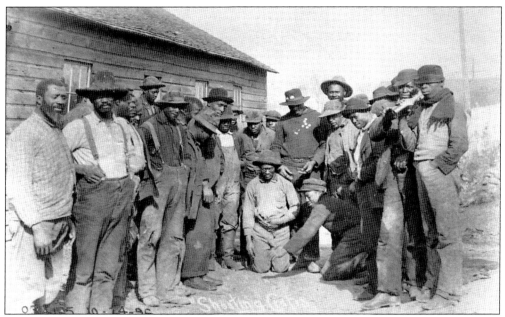

On September 3, 1892, ground was broken for the Chicago drainage canal, later to be renamed the Sanitary and Ship Canal. This new, 28-mile-long canal would run parallel to the old I&M Canal from Chicago to Lockport. This new canal would be one continuous waterway that engineers claimed would "sanitize" the sewage by the time it reached Joliet. Often working 10-hour days, nearly 8,500 laborers from a variety of ethnic backgrounds took advantage of camps constructed by the Sanitary and Ship Canal commissioners, which included mess halls and barracks. The c. 1897 photograph above shows a large group of African American workers playing dice during a break from construction work. The c. 1893 photograph below shows workers beginning construction on the massive Lockport Controlling Works lift gates in Lockport.

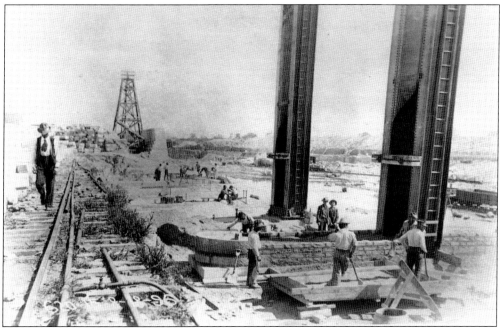

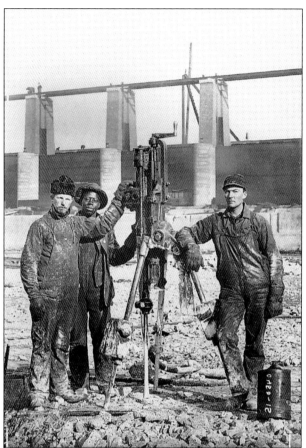

Completed in less than 10 years, the drainage canal was 160 feet wide and nearly 25 feet deep and was the largest earth-moving project in the world at that time. This Deep Cut project was dug through a low point on the subcontinental drainage divide, which helped to reverse the flow of the Chicago River toward the Mississippi River and the Gulf of Mexico. Digging a new canal with these extreme dimensions would protect the health of Chicagoans and would become a valuable commercial asset to the region. The photograph at left shows workers who drilled holes into limestone rock beds and used explosives during the construction phase between Lemont and Lockport. The photograph below shows a device used for hauling and stacking dirt and rock from the canal bed. The new technological devices used for the building of the Sanitary and Ship Canal were later employed to build the Panama Canal.

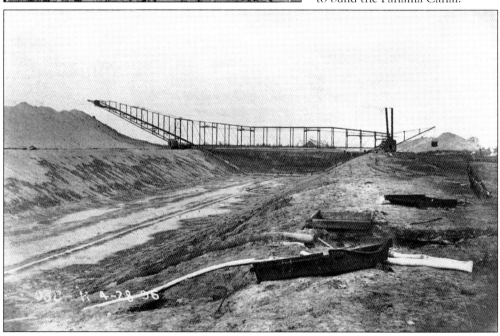

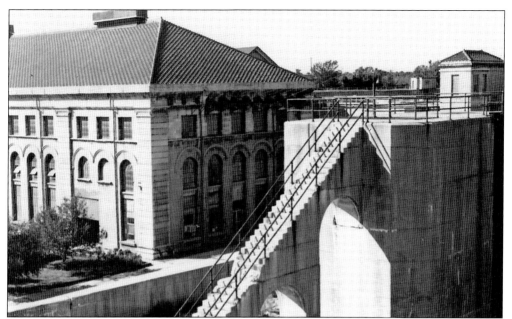

A major engineering achievement of the late 19th century was the construction of the Chicago Sanitary and Ship Canal. This canal was dug from Chicago to Lockport from 1892 to 1900 and extended to Joliet by 1907. It was 25 feet deep and 160 feet wide at its narrowest section. At Lockport, the channel widens to about 500 feet where large lake vessels could easily maneuver. Taking advantage of the 40-foot drop in elevation from Lockport to Joliet, the power plant was able to develop 40,000 horsepower, supplied Lockport with cheap power, and made it a manufacturing rather than a commercial city. The photograph above looking north shows the dam and lock, and part of the power plant is visible on the left. The photograph below shows a large turbine-driven power generation dynamo that produced electricity in the plant.

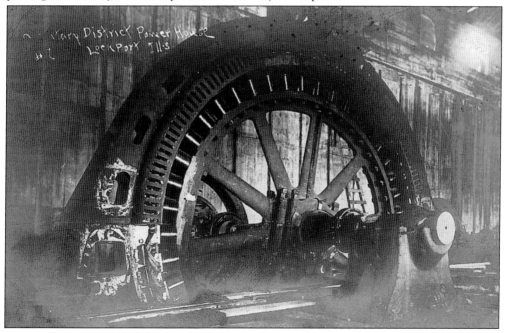

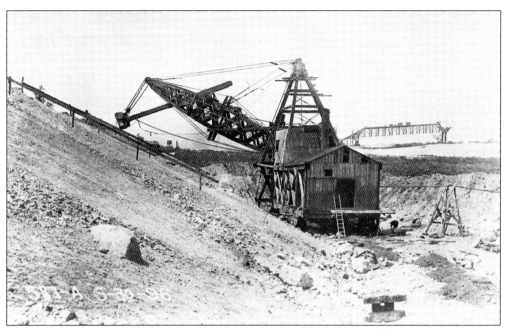

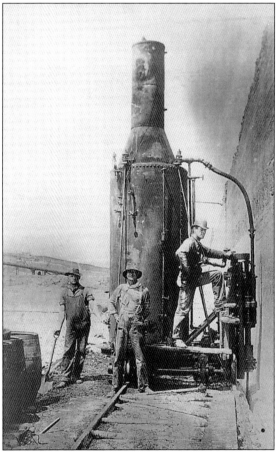

Construction of the eastern section of the Sanitary Ship Canal began in 1892; the portion between Chicago and Lockport took eight years to complete. The channel in this 28-mile section had a navigable depth of more than 20 feet and a width that varied between 110 and 201 feet. The construction techniques used to dig through the layers of soil in this location included the use of steam shovels and dynamite, in contrast to the building of the Illinois and Michigan Canal in the 1840s, when virtually all of the digging was done by hand using a variety of domestic- and foreign-born laborers. The c. 1894 photograph above shows a steam shovel used during the construction of the canal. The photograph at left shows steam-driven drilling equipment used to cut through the solid rock during Main Canal construction.

The main mechanism that controlled the flow of water through the Sanitary Ship Canal was located at the western terminus near Lockport. The unique feature of the work was Bear Trap Dam, which was 160 feet wide with a vertical play of 17 feet and seven sluice gates, each 30 feet wide with a vertical play of 20 feet. At the time of construction, the dam was the largest of its type and provided the means of controlling the flow of water through the canal. The dam went into operation on the morning of January 17, 1900. These pictures show views of the Bear Trap Dam and gates of the Sanitary Canal during construction. In later years, the drainage canal became part of the new Illinois Waterway and was used for transportation between the Great Lakes and the Illinois River.

Managing the discharge of water from the Main Channel of the Sanitary Ship Canal was the Lockport Controlling Works. In 1895 and 1897, two contracts were awarded for the construction of the Works, which consisted of a series of seven vertical gates, each 30 feet wide and 20 feet high, and a 160-foot-long dam called the Bear Trap Dam. If needed, the dam could be lowered to allow water to flow over the top, thus controlling a small amount of water being discharged into the canal and the Des Plaines River. If the water level of Lake Michigan increased rapidly, the seven vertical gates could also be raised to compensate for the water surge. These control structures in Lockport were among the largest in the world at the time. These pictures show different views of the dam in 1900.

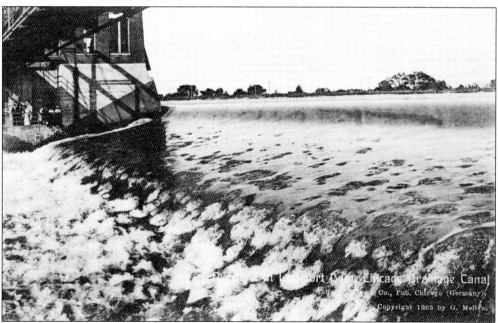

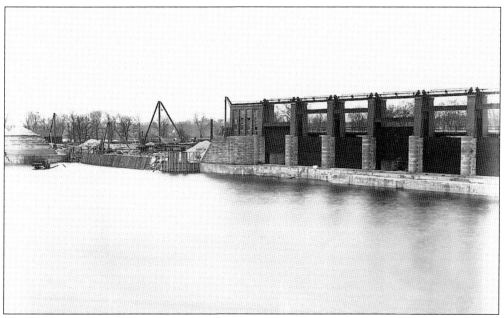

This 1890s photograph shows the controlling gates near Lockport. Between Lockport and Joliet is an abrupt fall of nearly 40 feet as the water begins to enter the Des Plaines River Valley. It is by means of these controlling works that the flow of water down the valley and past Joliet is done by simply opening or closing the great gates or valves and regulating the rate of water flow.

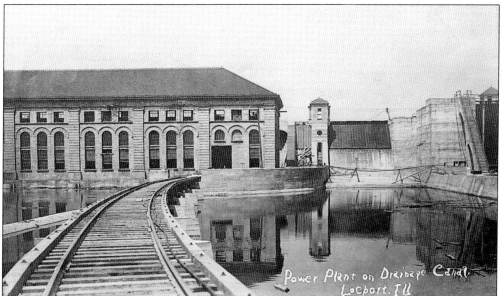

The Sanitary District power station was located one mile south of the controlling gates. The Sanitary Canal Power House was used to generate power by using water from the canal to drive turbines, which generated 40,000 horsepower of electrical power. Just to the right of this photograph is the small Bear Trap Dam, which controlled the flow of water to the power station and a lock, which allowed boats to commute from the Sanitary and Ship Canal to the old I&M Canal. The powerhouse became operational in 1907, and Lockport celebrated the facility's centennial in September 2007.

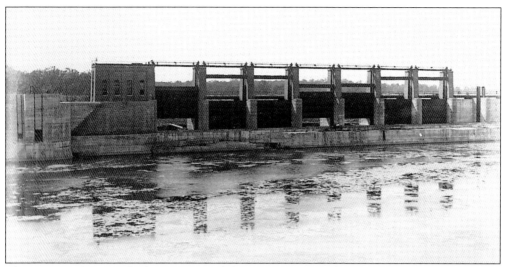

This c. 1900 photograph shows a view of the waste gates on the Sanitary and Ship Canal at Lockport. The waste gates were used to control the flow of water, which ran from Chicago to Lockport. Located out of view to the right is the Bear Trap Dam, which is designed to raise and lower according to the pressure on the exterior of the dam. It is also designed to control the water from the Sanitary Canal into the Des Plaines River.

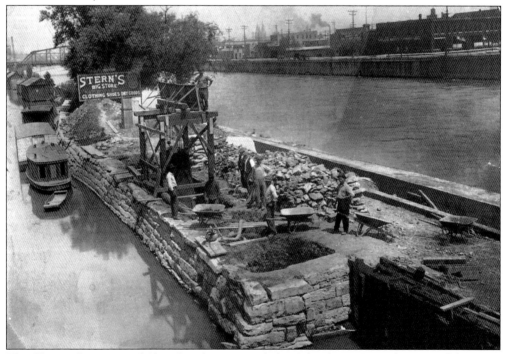

The Chicago Sanitary and Ship Canal was extended to Joliet by 1907. At the time of the Main Channel and extension construction, the Sanitary District of Chicago separated the I&M Canal and the Des Plaines River through Joliet. This allowed for increased flow in the river and still allowed navigation on the I&M Canal. This picture shows the two separate waterways that existed in Joliet in the late 19th century. The I&M Canal is on the left, and the drainage canal is on the right.

In 1889, the state of Illinois authorized the establishment of the Sanitary District of Chicago to deal with the sewage issue in the city, as the Deep Cut project and other ideas failed to keep the discharge of waste from entering Lake Michigan. As the drinking water became more unpalatable and Chicago's population increased to nearly 1.1 million, a decision was made to permanently divert and dilute the sewage by streaming it away in a larger and deeper canal. Isham Randolph, a civil engineer, served as the chief engineer for the digging of the Chicago Sanitary and Ship Canal and helped oversee the extension of the canal through Lockport. These c. 1899–1908 photographs show the original Lockport Controlling Works in various stages of construction. The two people in the photograph at right are dwarfed by one of the seven vertical gates, which measure 30 feet wide and 20 feet high.

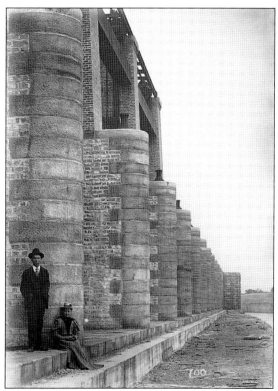

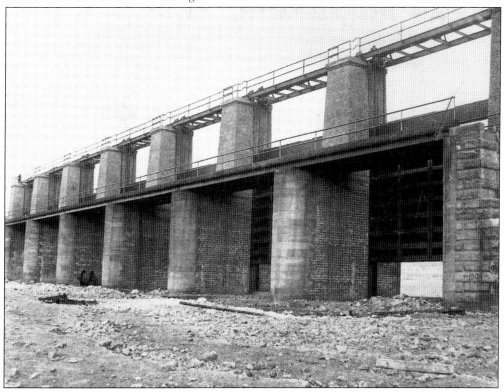

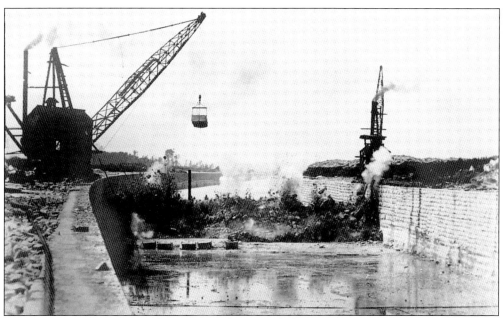

On May 8, 1899, Secretary of War R.A. Alger issued the permit that authorized the Sanitary District of Chicago to open the Main Channel of the Sanitary Ship Canal. At the time, the only concern that Alger had was the effect the diversion of water through the canal would have on the current in the Chicago River. When nothing came of those concerns, the district quietly, without ceremony, turned water into the Main Channel of the canal on January 2, 1900. There was a rush to divert the water in the canal shortly after completion; the city government of St. Louis felt the district's plan to pump water into the new canal might pose a threat to the Mississippi River water supply, and many feared a federal injunction might delay the project. A more formal opening took place two weeks later on January 17 when the Lockport Dam was opened at the southern end of the canal. Both photographs show the opening of a temporary dam at Kedzie Street that allowed water to flow into the canal in Chicago.

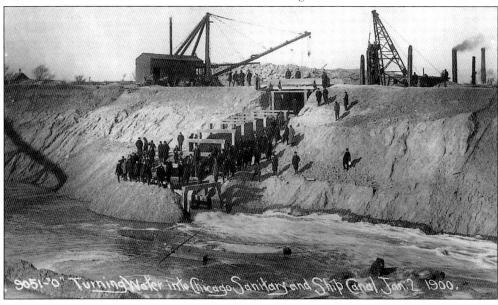

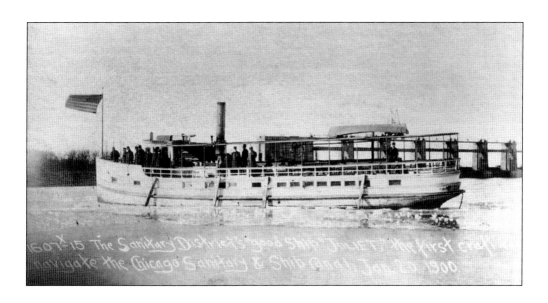

In the 19th-century, public health officials, physicians, and engineers understood the need to control the water supply and wastewater disposal in Chicago. It was believed that proper sanitation and a better water supply would protect city residents from epidemic outbreaks. In an effort to improve sanitation and navigation in Chicago, the Sanitary and Ship Canal was constructed between the South Branch of the Chicago River and Lockport, a distance of 28 miles. On January 2, 1900, sanitary district officials filled the Main Channel of the new canal. On January 20, 1900, an opening-day celebration was held, and the first boat, the *Juliet* (shown in these photographs), traveled along the new waterway.

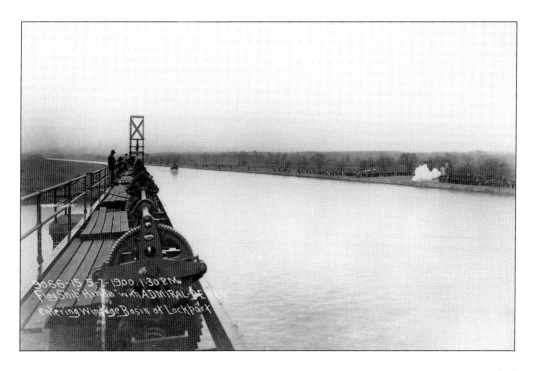

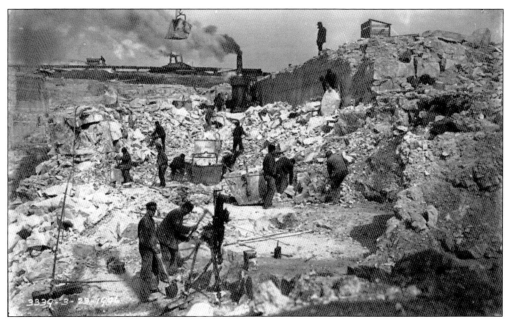

The Sanitary District began planning for the Cal-Sag Channel in 1907. This new channel would connect the Sanitary and Ship Canal with the Calumet River and create yet another outlet for water to drain and flow from Lake Michigan into the system by reversing the flow of the Calumet River. After a bit of legal wrangling, a permit was issued, ground was broken in 1911, and the new channel was completed by 1922. The construction of the Cal-Sag Channel and the dredging of the Little Calumet River attracted a diversity of individuals to the region, including Irish, Swedish, Dutch, German, and African American. As a result, the surrounding towns and villages, such as Dalton, Riverdale, Robbins, and Worth flourished as new industry followed the flow of workers to the area.

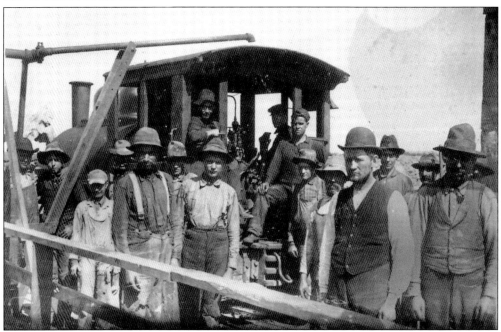

The Sanitary and Ship Canal was not the only plan the Sanitary District of Chicago had to divert water from Lake Michigan. Once the Main Channel was complete, city officials began a larger regional effort to use dilution as a solution to the pollution problem. Between 1907 and 1910, the sanitary district constructed the North Shore channel from Lake Michigan at Wilmette to the North Branch of the Chicago River at Lawrence. This eight-mile-long canal prevented sewage north of Chicago from draining into Lake Michigan by flushing the wastewater downstream into the Sanitary Ship Canal. Of the 8,500 workers who constructed the Sanitary Ship Canal, such as those pictured here, some were also employed on the North Channel project.

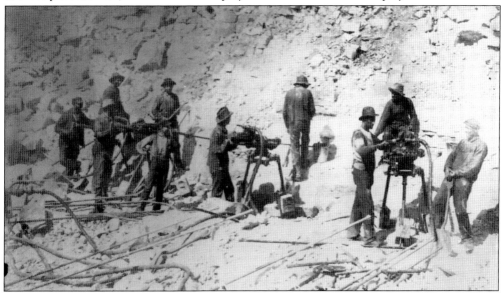

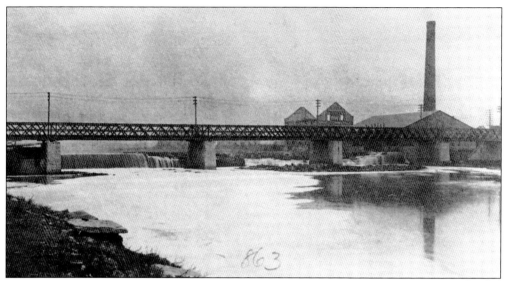

From McDonough Street on the south to Ruby Street on the north, Joliet has six lift bridges that span the Des Plaines River. The modern Scherzer Rolling Lift bridges are found at McDonough, Jefferson, Cass, and Jackson Streets. The c. 1900 photograph above shows the Jackson Street Bridge and Dam before it was raised to allow a greater water flow for the Economy Light and Power Company. In 1889, the Chicago Sanitary District was created, and construction began on a large canal to improve transportation and dilute waste and move it downstream. The section from the new Sanitary and Ship Canal from Lockport to Joliet was completed by 1907. Improvements to the Illinois and Des Plaines Rivers continued into the early 20th century, and the new Illinois Waterway was opened in 1933. The bottom photograph shows the Jackson Street Bridge today. (Below, courtesy Joe Balynas.)

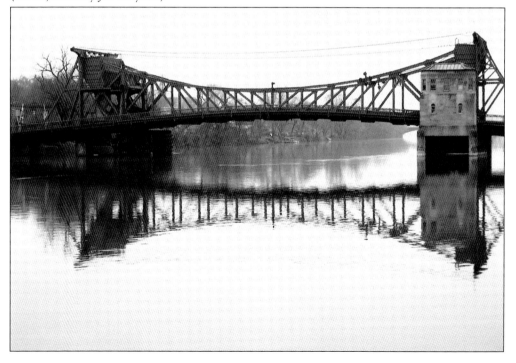

Much of the manual labor on the drainage canal involved the removal of stone in the final section of the project from Willow Springs to Lockport. This nearly 15-mile section contained millions of cubic yards of bedrock stone that needed to be excavated to build the canal. Some of the rock was hauled away from the construction site, sold, and used in other construction projects. Other rock was carved into blocks and used to construct the retaining walls along the canal. The c. 1895 photograph at right shows the large winches used to haul rock out of the construction area. The c. 1898 photograph below shows the construction techniques used to cut through the solid rock in this area.

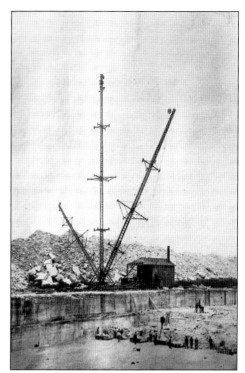

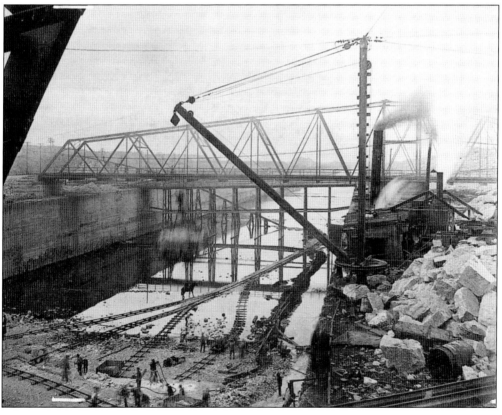

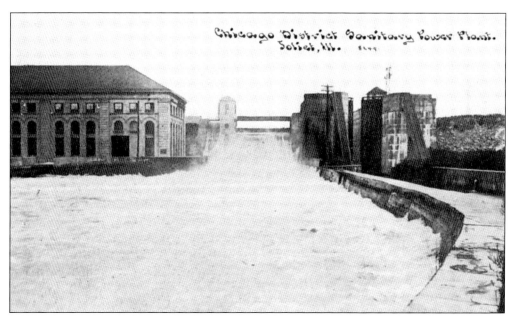

A 1903 law allowing for the generation of power on the canal led to the extension of the original Sanitary Canal to Lockport. In Lockport, two movable dams, a lock, and a power house were constructed following the design plans of Isham Randolph. A smaller version of the Bear Trap Dam was located at the sanitary district power station, nearly two miles south of the Lockport Controlling Works and Dam. The small Bear Trap Dam controlled the flow of water to the power station. Taking advantage of the 40-foot drop in elevation from Lockport to Joliet, the power plant was able to develop 40,000 horsepower, supplied Lockport and parts of the region with cheap power, and made it a manufacturing rather than a commercial city. Both photographs looking north show the dam and the power plant on the left.

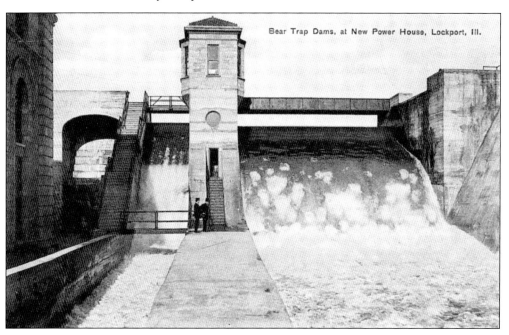

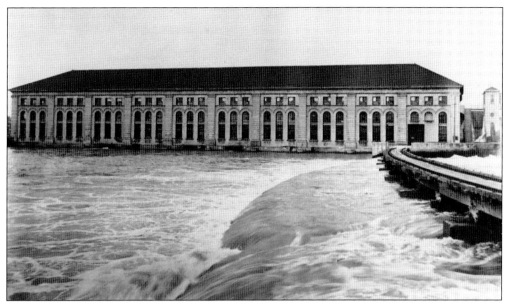

Between 1903 and 1907, the Main Channel of the Chicago Sanitary Ship Canal was extended nearly four miles from the Lockport Controlling Works to the Upper Basin in Joliet. The extension included the construction of the Lockport Powerhouse, which was designed by Frederick L. Barrett in Beaux Arts style using concrete blocks laid to simulate stone. Built between 1905 and 1907, the red-roof powerhouse plant measures 385 feet by 70 feet and continues to provide hydroelectric power to the area. The original four horizontal Francis-style turbines inside the facility that generated electrical power were replaced by two vertical Kaplan-style turbines that still operate today. Recently, the Federal Energy Regulatory Commission recognized the powerhouse as the oldest hydroelectric project in Illinois. In 2004, the Lockport Dam and Powerhouse were added to the National Register of Historic Places. These photographs show unique views of the powerhouse complex.

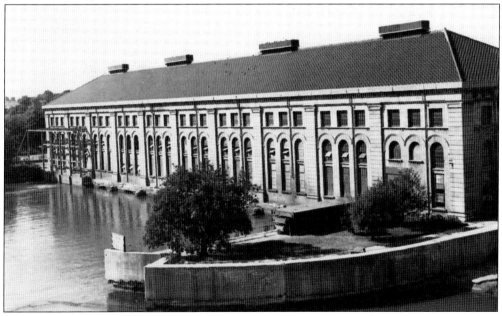

In 1919, the Illinois General Assembly passed legislation to authorize the construction and development of the Illinois Waterway, a project designed to provide a navigation channel between Lockport and Utica. Construction of this modern Illinois Waterway project, which would eventually make the I&M Canal obsolete, was started by the state of Illinois and completed by the U.S. Army Corps of Engineers in 1933. These photographs show the construction of the Illinois Waterway walls through Joliet. Note the elaborate construction techniques used to mold the concrete retaining walls through the area. The height of the new concrete walls allowed for the increased flow and volume of water in the system beginning in the 1930s. Today, the modern Illinois Waterway includes a network of lock-and-dam complexes along the Calumet River, the Chicago Sanitary & Ship Canal, and the Illinois River. These lock-and-dam complexes include the O'Brien Lock, Lockport, Brandon Road in Joliet, Dresden Island in Morris, Marseilles, Starved Rock, Peoria, and downstate La Grange. A lock also operates at Chicago Harbor. The Illinois Waterway is a shipping route stretching from Chicago all the way to the Mississippi River north of St. Louis.

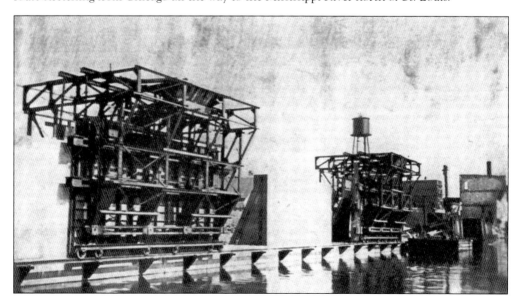

The Lockport Lock, Dam, and Powerhouse were built during two separate periods of construction. The first phase, 1905–1907, dates to the extension of the Chicago Sanitary and Ship Canal in which the original lock, a tailrace, guide walls, sluice gates, and the powerhouse were constructed. During the second phase, 1922–1933, the Ohio River Standard Navigation Lock, control station, and other auxiliary structures were constructed as part of the building of the Illinois Waterway. The state of Illinois designed the new Ohio River Standard Navigation Lock, measuring 110 feet wide by 600 feet long with a 41-foot lift; it was the largest in the United States at the time. The new lock was built immediately adjacent to the original lock and the powerhouse. The c. 1932 photograph above shows the construction of the new Lockport Lock. The c. 1947 photograph below shows the inside of the lock during repairs.

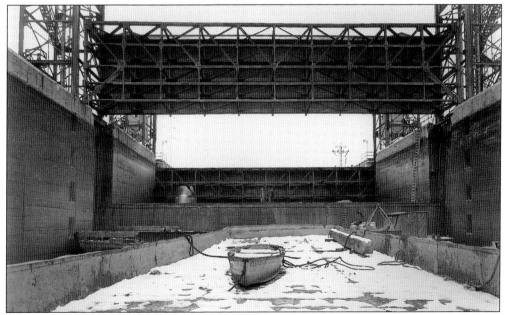

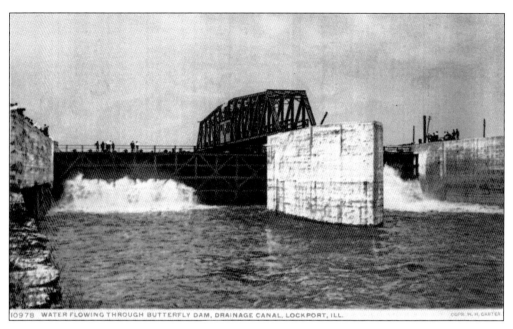

10978 WATER FLOWING THROUGH BUTTERFLY DAM, DRAINAGE CANAL, LOCKPORT, ILL.

An emergency controlling mechanism called a Butterfly Dam was created to control the flow of water in the system. The movable dam was located near the end of the 28-mile Chicago drainage canal and at the entrance to the waterpower extension in Lockport. The dam took on this unique name because the valves (called butterfly valves) that opened and closed moved on horizontal pivots. The concept was to construct a dam, 184 feet long and 30 feet high, which could regulate the flow of water by opening and closing the valves. The normal position of the dam is in the center of the channel, but when the channel needed to be closed, the dam was turned into the current by means of a rack-and-pinion mechanism operated by an electric motor. These photographs show views of the Butterfly Dam.

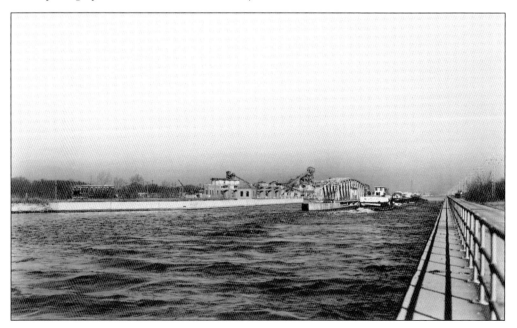

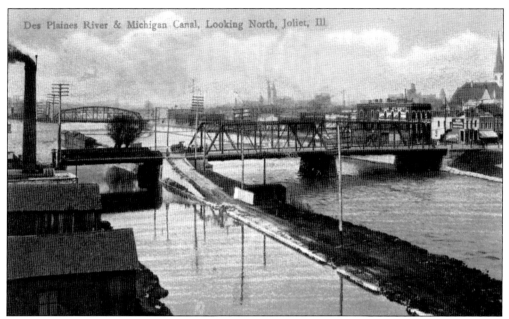

During the 1890s, the Metropolitan Sanitary District separated the Illinois and Michigan Canal and the Des Plaines River to allow for increased water flow of the Chicago Sanitary Ship Canal. The postcard photograph above looking north near the Cass Street Bridge shows the I&M on the left and the Des Plaines River on the right. The c. 1931 photograph below shows the construction of the Illinois Waterway through Joliet in the 1930s. The new waterway extension made the Illinois and Michigan Canal obsolete, and once the construction was complete, the towpath that separated the river from the canal would be submerged. In this photograph, workers are erecting cement walls along the west side of the waterway, which would allow for the height of the river to be raised.

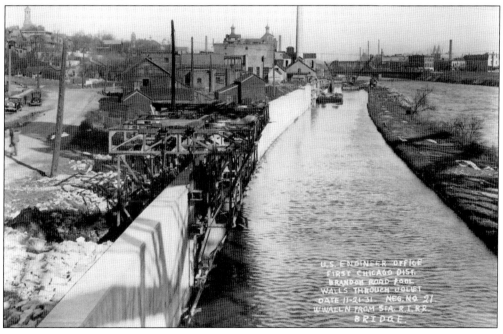

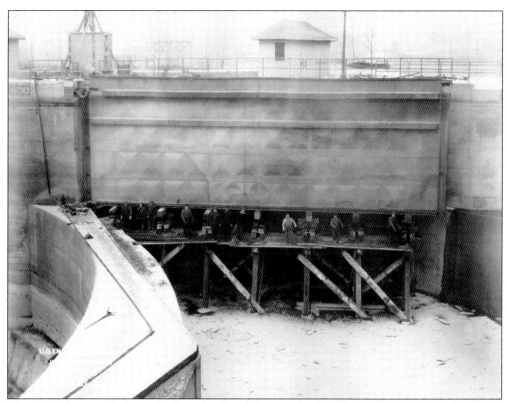

This 1932 photograph shows the Brandon Road Dam on the Des Plaines River, just south of Joliet near Rockdale. On the Illinois Waterway, eight dams hold back water to form eight "pools" very similar to long, narrow lakes. These dams raise the water level enough to accommodate the large tows that require nine feet of water to operate. This arrangement creates a "stairway of water" that drops 163 feet from Lake Michigan to the Mississippi River.

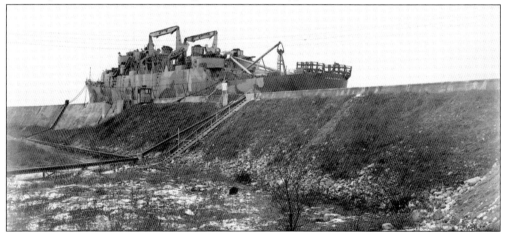

The construction of the modern Illinois Waterway was started by the state of Illinois in 1920. By 1930, about two-thirds of the work was completed, and the entire project was turned over to the US Army Corps of Engineers, which resumed construction and opened the waterway on June 22, 1933. This c. 1945 photograph shows an oceangoing vessel moored along the east wall of the Brandon Road Lock.

Six

Civilian Conservation Corps

The Great Depression saw an unemployment rate of more than 25 percent in the early 1930s, and Pres. Franklin Roosevelt proposed legislation aimed at providing some relief for unemployed Americans within weeks of his inauguration. Faced with a bleak economic outlook, Roosevelt's plan called for the recruitment of thousands of unemployed young men to enroll in a peacetime army to battle against the destruction and erosion of the country's natural resources.

Roosevelt signed into law the Emergency Conservation Work Act establishing the Civilian Conservation Corps on March 31, 1933. Roosevelt believed that by early summer, temporary employment would be provided to nearly 250,000 young men and an additional 50,000 workers would comprise war veterans, men from Indian reservations, and local experienced men from around the country. From 1933 to 1942, over three million young men joined the CCC and contributed to the protection, conservation, and development of the country's environmental resources.

In Illinois, the CCC employed nearly 6,600 men in nearly 50 camps, including a state forest, state parks, private land forests, and erosion and flood control. Several of these camps were located along the I&M Canal and accomplished many projects, including clearing brush, restoring the towpath, developing parks, restoring locks and gates, and repairing aqueducts and buildings.

CCC camps catered to different enrollment sizes, and conservation projects varied by regional needs and concerns. Enlistment requirements were simple for all camps: unemployed, unmarried, healthy, and between the ages of 18 and 25. As the program grew, other groups also joined the ranks of the CCC, including African Americans, Native Americans, and Mexican Americans. The CCC camps provided these young men with educational, recreational, and job-training opportunities.

Today, it is not difficult to discover surviving CCC work projects around Illinois, especially in certain state parks or along the I&M Canal. Examples include shelters at Starved Rock, Gebhard Woods, Giant City, Illini, Mississippi Palisades, Pere Marquette, Trail of Tears, and White Pines, among others. Foot trails, rock campfire rings, cabins and lodges, dining halls, bridges, benches, tables, signs, and horse trails also were built at numerous parks and other locations.

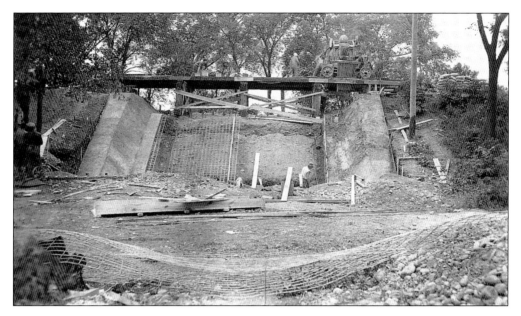

Eligibility requirements for the CCC carried several simple stipulations. Congress required U.S. citizenship only. Other standards were set by the Emergency Conservation Work Act (ECW). Sound physical fitness of the enrollees was mandatory because of the hard physical labor required. The War Department mobilized the nation's transportation system to move thousands of enrollees from induction centers to work camps. The popularity of the CCC program was confirmed by the high rate of re-enlistment and the increasing number of new applicants. Many men, including those in Illinois, re-enlisted for an additional six months of service, up to a maximum of two years. After 1940, the average length of service would drop, as many CCC enrollees would find employment opportunities in the war industries. The photograph above shows the bypass constructed along the canal for water overflow, and the photograph below shows the restored gates of Lock No. 6 shortly before being put back into operation.

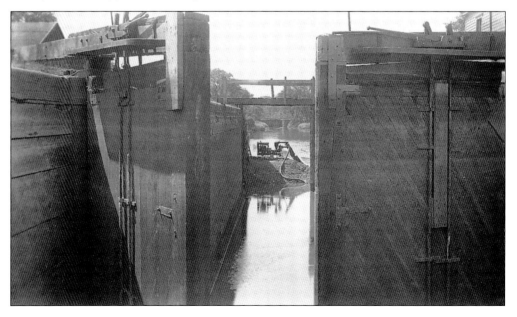

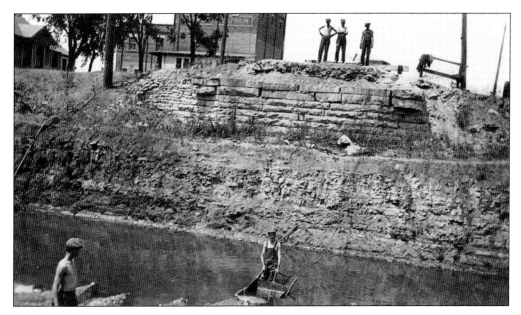

Targeting unemployed young men hard hit by the Great Depression, the CCC assigned these enrollees into work camps across the country with various conservation projects. From 1933 to 1942, over three million young men joined the CCC and contributed to the protection, conservation, and development of the country's environmental resources. Work included planting trees, fighting fires, improving parks and recreation areas, constructing roads, building drainage ditches, and installing telephone and electrical wires. The CCC camps provided these young men with educational, recreational, and job training opportunities. Despite the army's role in administering the CCC, the camps were civilian rather than military in character. There were no military drills, no manuals of arms, and no military discipline. The photograph above shows men at work on the I&M Canal in Romeoville. The photograph below captures a recreational game of tug-of-war at McKinley Woods in Channahon.

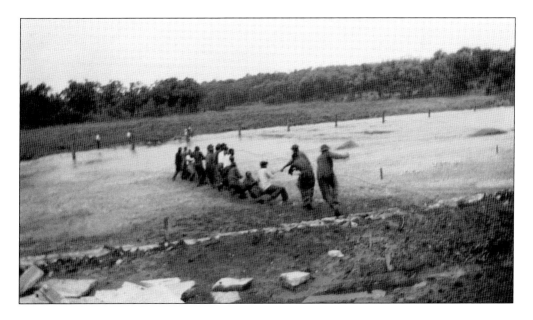

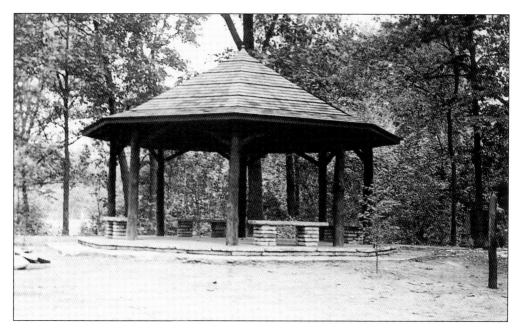

In April 1933, the nation's first CCC camp, Camp Roosevelt, opened in the George Washington National Forest in Virginia. By July 1, 1933, the goal of enlisting a quarter million enrollees, in over 1,300 camps, had been accomplished. The sheer scope of this ambitious undertaking required a logistics system that operated with several government agencies working together. For example, the Department of Labor recruited and selected the men, the War Department housed, clothed, fed, and trained the men for two weeks and organized and administered the camps, and the Department of Agriculture designed and planned the work details, recommended camp locations, and supervised the work programs. CCC camps catered to different enrollment sizes, and conservation projects varied by regional needs and concerns. These photographs show local examples of picnic shelters and a bridge that were typical of work projects along the canal in Illinois.

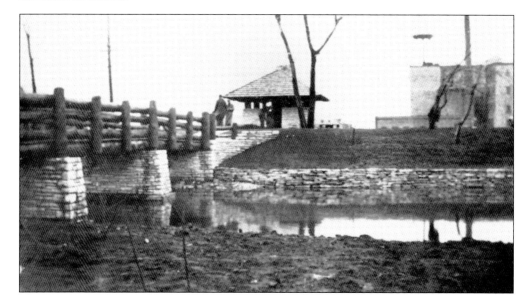

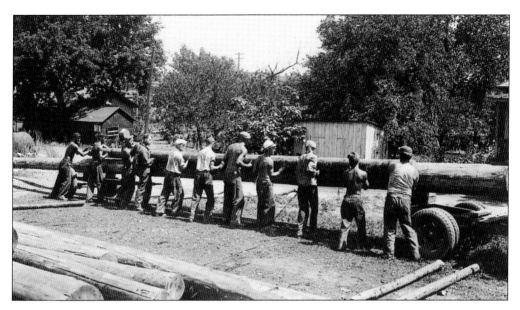

Each CCC camp was located in the general area of the conservation work projects that needed to be performed. A typical camp was organized around a group of 200 or more civilian enrollees who were given a "company" number and mimicked a military environment, including officer quarters, mess halls, recreational halls, lavatories, showers, medical buildings, tool rooms, and motor pool garages. In the early years, surplus army tents were utilized to house the enrollees, but over time, inexpensive, prefabricated, and portable buildings were common in most camps. At Starved Rock State Park, several work camps were in operation over the course of several years, beginning in 1933. These include Camps 614, 1609, and 2601. Each work camp performed different tasks and projects, including constructing trails, shelters, benches, log cabins, the elegant lodge building, and parking lots, and planting trees and flowers. The goal of the CCC camps was to preserve the park from erosion, flooding, and deforestation, while making it a destination. These photographs show CCC workers constructing the Starved Rock Lodge in the late 1930s.

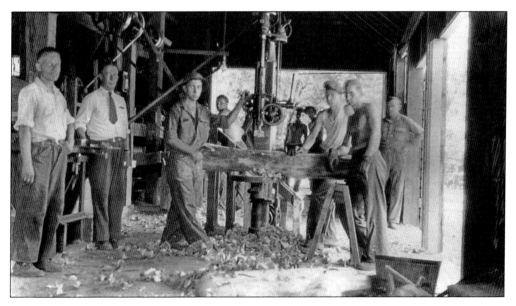

The organizational structure of the CCC followed the nine regional corps areas, which were identical to the existing army corps divisions. Each of the nine corps areas was commanded by an army general, later replaced by reserve officers. These leaders were responsible for overall camp operation, logistics, education, and training. Besides improving the nation's parks and forests, CCC men also improved themselves with on-the-job training, education programs, reading and writing instruction, and specialized vocational classes offered in some communities. In the evenings, 90 percent of enrollees took advantage of classes offered in subjects from literature to welding—courses which, over nine years, taught 40,000 illiterate men to read and write. Erosion control, flood control, structural improvements, and landscape and recreation development were general classifications of work projects completed along the I&M Canal. The photograph above shows a stone dock constructed along the Illinois River near McKinley Woods, and the photograph below shows a typical towpath turnout that was constructed along the canal to allow cars to pass.

Early enrollees in the CCC lived in drafty tents, were issued poor, ill-fitting uniforms, and given subpar food allotments. By the second year of the program, the men were living in quasi-military encampments that included cabins, three square meals a day, an eight-hour work detail, education classes, and recreational time. CCC workers received a wage of $30 per month, $25 of which was mandatorily sent home to their families. This c. 1937 photograph shows the workers' barracks at McKinley Woods in Channahon.

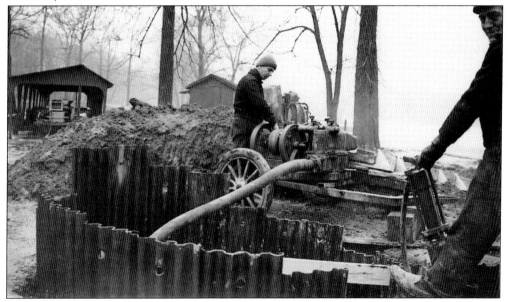

The CCC did extensive work on the I&M Canal from Chicago to LaSalle between 1935 and 1936. The CCC worked on city parks and forest preserves along the canal, and even restored Locks No. 6 and No. 7 in Channahon along with the locktender's house. The men of the CCC also built shelters along the canal, and examples of their work can still be seen in the park. This photograph shows CCC workers attempting to drain the canal in McKinley Woods in Channahon.

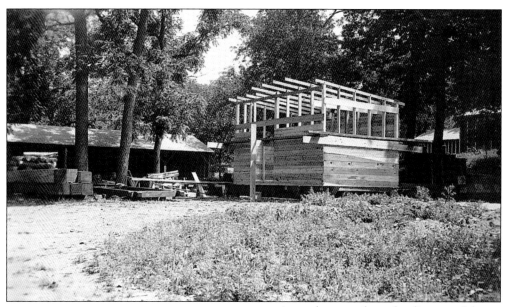

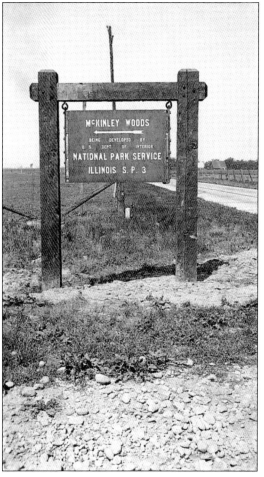

Annual reports from the director of the Civilian Conservation Corps provide some indication of enrollment totals for the state of Illinois, but often monthly enrollment totals reflected in these reports do not provide an actual month-to-month total for each camp. Historic records also do not provide a clear picture of the total number of camps that operated in the state, and certain sources provide an average number. The 1939 Annual Report lists 49 camps in operation in Illinois, including several larger camp areas that had between 180 and 200 enrollees each. The type of general tasks varied with the type of park (e.g., soil conservation service, state park, county forest preserve, drainage camp, or army base). The six camps along the I&M Canal were devoted to construction—foot and vehicle bridges, horse bridges, shelters, buildings, benches, and tables, along with water control and landscaping. CCC constructions can still be seen in several state parks. These photographs show CCC work at McKinley Woods in Channahon, including the barracks used by CCC workers and the camp sign for McKinley Woods.

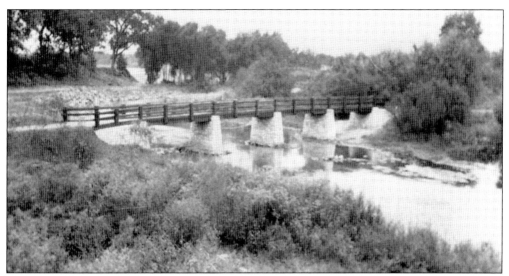

The Channahon Access first became a state park in 1932, known then as the Channahon State Parkway. The I&M Canal officially closed in 1933 with the opening of the new Illinois Waterway. Over time, the canal and the surrounding region became neglected and were in need of cleanup and repairs. In the 1930s, the CCC was assigned to clean and repair areas around the canal. The young men of the CCC also built shelters along the canal, and examples of their work can still be seen in the parks throughout Illinois. The c. 1935 photograph above shows a footbridge stretching across the DuPage River, and the photograph below from about the same time shows CCC workers digging a drainage ditch near Channahon.

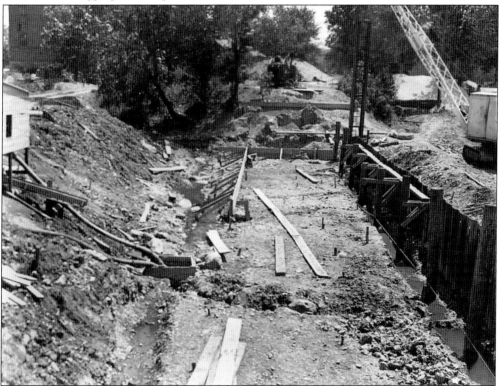

By the end of 1939, the death of Director Robert Fechner, a decline in morale among CCC supporting agencies, uncertainty due to the outbreak of war in Europe, and proposed budget cuts foreshadowed trouble for the CCC. Although the CCC was considered to be one of the most popular New Deal programs, it never was intended to become a permanent agency. After December 1941, all federal programs were revised and augmented to cater to the war effort. Congress ceased funding the program, causing the CCC to officially conclude operations on June 30, 1942. Throughout its nine-year history, the CCC faced management problems, racial tensions, and perception issues within the local communities—the legacy it created, especially after World War II, can be found in its ability to be a model for conservation programs, youth training, educational activities, and community service. In the end, the CCC improved the nation's natural resources and had a profound and lasting effect on the young men enrolled in its programs. These photographs show CCC worksites along the canal in Grundy and LaSalle Counties.

On August 24, 1984, Pres. Ronald Reagan signed a bill authorizing the creation of the I&M Canal National Heritage Corridor. This new legislation established a nearly 100-mile-long cultural park between Chicago and LaSalle-Peru that became the nation's first National Heritage Corridor. The notion of linking public and private space along the canal into a new, open-space, planning-and-awareness concept was an innovative and radical way to embrace the history of the canal corridor. The new open-space planning idea helps to bring together preservation, conservation, recreation, and economic development of the region. While the legislation became law in 1984, the origins of bridging a successful mixture of preservation, public use, and industrial activity can be traced back to the CCC restoration efforts of the 1930s. These photographs show CCC workers employed in the ambitious program of transforming the I&M Canal into a recreational parkway destination.

BIBLIOGRAPHY

Cozen, Michael and Kay Carr. *The Illinois and Michigan Canal National Heritage Corridor.* DeKalb, IL: Northern Illinois Press, 1988.

Genealogical and Biographical Record of Will County, Illinois. Chicago: Biographical Publishing Company, 1900.

Harlow, Alvin C. *Old Towpaths: The Story of the American Canal Era.* Port Washington, NY: Kennikat Press, 1964.

Lamb, John M. "Early Days on the I&M Canal." *Chicago History* 3 (Winter 1974–1975): 168–170.

Lockport, Illinois: An HCRS Project Report. Washington, DC: US Department of the Interior, Heritage Conservation and Recreation Service, 1980.

Putnam, James W. *The Illinois and Michigan Canal.* Chicago: 1918.

Ranney, Edward and Emily J. Harris. *Prairie Passage: The Illinois and Michigan Canal Corridor.* Champaign, IL: University of Illinois Press, 1998.

Sereno, Ken and Deborah Steffes. *Morris: A Nostalgic Portrait.* St. Louis: G. Bradley Publishing, 2007.

Sterling, Robert E. *A Pictorial History of Will County.* 2 Vols. Joliet, IL: Will County Historical Publications Company, 1975–1976.

Sterling, Robert E. *Joliet Transportation & Industry: A Pictorial History.* St. Louis: G. Bradley Publishing, 1997.

Woodruff, George H. *Forty Years Ago! A Contribution to the Early History of Joliet and Will County.* Joliet, IL: Joliet Republican Stream Printing House, 1874.

Yeager, J. *Illinois.* Philadelphia: H.C. Carey & I. Lea., 1823.

INDEX

Armour Warehouse, 70
Ashland Avenue, 13
Aux Sable Creek, 59, 60
Aux Sable Aqueduct, 59, 60
Barrett Hardware, 30
Bear Trap Dam, 97, 98, 108
Bluff Street, 33
Brandon Road Dam, 114
Briscoe Mounds, 47
Bubbly Creek, 13
Butterfly Dam, 112
Cal-Sag Channel, 104
Canal Street, 77
Channahon Dam, 49, 50
City of Pekin, 46
Chicago Portage, 15, 16
Chicago Street, 38
Coleman Hardware, 66, 67
Damen Avenue, 15
Dayton, 76
Dresden, 59
Dresden Inn, 58
DuPage River, 47, 68
Economy Light and Power Co., 34, 35,
Fitzpatrick, Patrick, 28
Fox River, 72
Fox River Aqueduct, 72, 73
Fox River Feeder Canal, 75, 76
Gaylord Building, 22
Gebhard Brewery, 66, 67
Gebhard Woods, 66
Hegeler-Carus Mansion, 83
Hogan Grain Elevator, 70
Hossack Grain Elevator, 78
Illinois Central Railroad Bridge, 85
Illinois Steel Works, 38, 39
Jackson St. Bridge, 34, 36, 106
Jefferson Street, 37

Jefferson St. Bridge, 36, 37, 106
Juliet, 103
Kankakee Feeder Canal, 44, 51
Kankakee Navigation Co., 41, 42
Kankakee River, 16, 41, 42, 44
LaSalle Street, 75
Lateral Canal, 74, 75, 77, 78
Lateral Canal Lock, 74
Leach Windmill Co., 33
Lime kiln, 17
Little Vermilion River Aqueduct, 85
Lock No. 1, 27
Lock No. 6, 52, 53, 54, 55, 56, 68, 116
Lock No. 7, 52, 57
Lock No. 8, 60, 61
Lock No. 9, 71
Lock No. 13, 71
Lock No. 14, 87
Lock No. 15, 87
Lock Street, 14
Lockport Controlling Works, 90, 92, 93, 99, 100, 101
Lockport Power Plant, 95, 99, 108, 109
Lockport Township High School, 25
Locktender's house, 52, 53
Martin Hogan, 2
Marquette, Fr. Jacques, 15, 80
McKinley Woods, 51, 117, 120, 121, 122
Mill Pond, 42
Mill Street, 75
Minooka Widewater, 48
Mud Lake, 11, 16
Nashota, 2
Nettle Creek Aqueduct, 63, 64
Norton Flour Mill, 20

Oliver Oatmeal Mill, 32
Ottawa Tollhouse, 79
Peerless, 2
Polygon Mill, 86
Porter, Edwin, 31
Public Square, 24
Reddick, William, 80
Robey Street Bridge, 15
Rock Island Elevator, 12
Ruby Street Bridge, 36, 106
Sanitary District Power Plant, 95, 99, 108, 109
Seneca Grain Elevator, 70
Scutt, Hiram, 33
Split Rock, 82
St. Anthony's, 58
St. Dennis, 26
St. John's, 26
St. Rose, 43
Starved Rock, 119
State Street, 28
Steel Works Club, 40
Summit Lock, 17
Superior Street, 74, 76
Superior Street Lock, 74, 76
Union Stock Yards, 13, 14
Utica Grain Elevator, 81
Washington Park Square, 79, 80
Westclox Watch Co., 84
Wilmington Light and Power Co., 43
Woelfel Tannery, 66, 68

127

Discover Thousands of Local History Books Featuring Millions of Vintage Images

Arcadia Publishing, the leading local history publisher in the United States, is committed to making history accessible and meaningful through publishing books that celebrate and preserve the heritage of America's people and places.

Find more books like this at
www.arcadiapublishing.com

Search for your hometown history, your old stomping grounds, and even your favorite sports team.

Consistent with our mission to preserve history on a local level, this book was printed in South Carolina on American-made paper and manufactured entirely in the United States. Products carrying the accredited Forest Stewardship Council (FSC) label are printed on 100 percent FSC-certified paper.